IMAGES
of America

YAKIMA
WASHINGTON

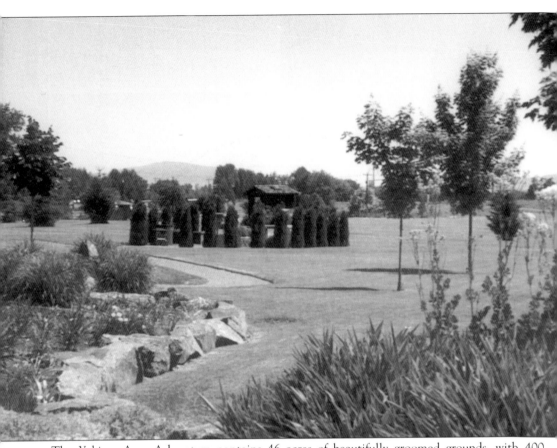

The Yakima Area Arboretum contains 46 acres of beautifully groomed grounds, with 400 different kinds of trees and shrubs. Both native and non-native species are on display, many carefully labeled. Flowering trees show their color in April and May, while other deciduous trees such as oaks throw down their colorful blankets in October. Other highlights include a Japanese garden, a wetland trail complete with beaver pond, and a small grove of sequoias. The Jewett Interpretive Center has a self-guiding trail map. Even though it is right off the highway, the arboretum is a peaceful place for relaxation.

IMAGES
of America

YAKIMA

WASHINGTON

Elizabeth Gibson

ARCADIA

Copyright © 2002 by Elizabeth Gibson.
ISBN 0-7385-2086-1

Published by Arcadia Publishing,
an imprint of Tempus Publishing, Inc.
3047 N. Lincoln Ave., Suite 410
Chicago, IL 60657

Printed in Great Britain.

Library of Congress Catalog Card Number: 2002112085

For all general information contact Arcadia Publishing at:
Telephone 843-853-2070
Fax 843-853-0044
E-Mail sales@arcadiapublishing.com

For customer service and orders:
Toll-Free 1-888-313-2665

Visit us on the internet at http://www.arcadiapublishing.com

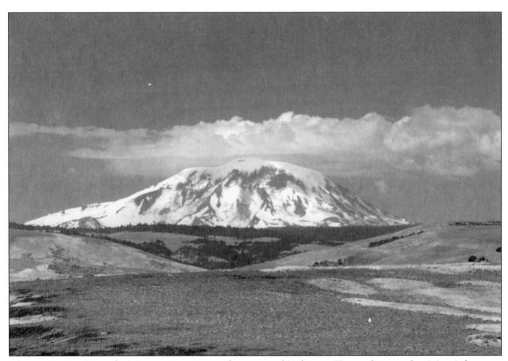

The majestic Cascade Mountains rise to the west of Yakima. Two of its peaks, Mt. Adams at 12,276 feet and Mt. Rainier at 14,410, watch over Yakima. Pictured is Mt. Adams, visible to the southwest. Mountain climbers who want to train before tackling the really big peaks often use this mountain. Some imagine they can see an outline of a horse in the contours of the mountain.

CONTENTS

ACKNOWLEDGMENTS

Ken C. Brovard
109b, 110a, 115a, 115b

Capitol Theater
110a–113b, 114b

Beth Gibson
2, 4, 13, 14, 18b, 20a–21b, 22a, 23a–24b, 25b, 26a, 26b, 27a, 28a, 28b, 29b, 30a–32a, 36a,
36b, 40a, 51a, 52a, 53a, 54b, 55b, 56a, 64b, 67, 68a, 76, 77b, 78a, 80a, 82, 94, 95, 96a, 97a,
105, 109a, 114, 117b, 118a, 120a–128b

McAllister Museum of Aviation
61-64a, 65a-66b

St. Joseph-Marquette Middle School
11a, 100a, 101a–103

Kathleen Wagner
48b, 68b, 71b, 72a, 72b, 73a, 78b, 79a, 79b, 80b, 83b, 84a

Yakima Training Center
85–93b

Yakima Valley Museum
9, 10a, 10b, 11b, 12a, 12b, 15b, 16a, 16b, 17a, 25a, 27b, 34b, 35a, 35b, 37a, 43a, 43b, 49, 50a,
50b, 52b, 53b, 54a, 55a, 57a–59b, 69a, 70b, 71a, 75b, 104, 116a, 116b, 117a

Yakima Valley Museum, George Martin Collection
15a, 19, 42a, 81a, 106a

Yakima Valley Museum, Lanterman Collection
17b, 18a, 22b, 29a, 32b,

Yakima Valley Regional Library, Relander Collection
34a, 81b

JoAnne Young
30b, 33, 46b, 51b, 56b, 60a, 69b, 70a, 77a, 83a, 84b, 96b, 98, 99a, 99b, 100 a–b, 106b–108b

Yakima School District
37b-39b, 40b, 41a, 41b, 42b, 44a–46a, 47a, 47b, 48a, 73b-75a, 118b, 119a, 119b

INTRODUCTION

The Yakama Indians were the first people in the Yakima Valley. A series of battles in the 1850s led to confinement of the Indians to a nearby reservation. After the Indians were subdued, immigrants began settling in the area. Fort Simcoe was established in 1856 to ensure peace in the valley; however, as a military installation, the fort was short lived. In just two years, the fort established a school for Yakama Indian children, and Father James Wilbur began teaching the Indian families how to grow their own crops. Many of the names of communities in the Yakima valley are derived from Indian words: Yakima, Moxee, Tieton, Cowiche, Selah, Naches, and Wapato.

Now that the land was quiet, Yakima County was established in 1865. In 1869, the first store was built in Yakima City. By 1880, 267 people lived in town and almost 3,000 people lived in the county. In 1884, the Northern Pacific railroad was planning to locate a depot in the vicinity. Yakima City looked good, but the property owners would not meet the railroad's terms. The residents felt they should be well paid for the land forfeited for the right of way. The railroad felt the land should be given free because of the new business the railroad would bring. Instead, the railroad settled on another location, four miles north of Yakima City. The new town was named North Yakima. The railroad offered complete payment of expenses for anyone who wished to move their home or business to the town. Most went, because Yakima City was doomed to die with diversion of all traffic to the north.

On January 27, 1886, the new city of North Yakima was incorporated. By 1889, there were 62 businesses in the city. One of the first improvements to the new town was to install water mains and fire hydrants. Within three years, citywide phone service was available, and soon after the turn of the century, Yakima sported a city-wide electric trolley system. Within the first decade Yakima Avenue and several blocks worth of cross streets received asphalt paving. And, it seems, there has always been at least one newspaper to report on the progress of the city.

The town grew quickly due to its successful exploitation of the fertile volcanic soil. Bumper crops of apples, peaches, hops, and grapes among other farm products put Yakima in the agricultural spotlight. The presence of the Yakama Indians was still felt, as many of them took jobs picking hops for the farmers. The livestock industry also flourished, with several breeds of cattle and sheep being annually placed on the market. As a hub for the Northern Pacific Railroad, Yakima could get those commodities to market quickly.

In 1918, North Yakima was reincorporated as the city of Yakima. The original Yakima City became known as Union Gap. Both attracted their share of businessmen to the town, bringing innovative ideas. Widespread irrigation projects led to larger agricultural production. Timber also played a big part of Yakima's early economy, supplementing farming and ranching related businesses. A sawmill was erected on the Yakima River; timber from the upper Yakima River and Teanaway Rivers were floated down the river to the mill.

Many other men came and left their mark on Yakima. Frederick Mercy arrived and installed several theaters throughout Yakima and the rest of the state. Chester Congdon would grow one of the largest orchards in the valley, which survives to this day. J.M. Perry, an early fruit packer and shipper, left funds to establish what would become a nationally renowned technical school.

Alexander Miller and A.E. Larson would contribute greatly to the growth of Yakima with their own businesses as well as those they helped fund.

Though everyone suffered during the Great Depression, Yakima seemed less affected than most. Wages were still low and many people were out of work. But there was plentiful food in the valley and everyone shared with their neighbor. People made use of their fruit cellars and canning, they used surplus produce to pay bills, and everyone learned to make do with less and did not complain.

The valley did not remain unaffected throughout the World Wars; local boys went off to war and did not come back, and the valley suffered its own shortages and rationing. During these years, the U.S. Army established an army-training center north of the city, for training and artillery practice for National Guard and U.S. army troops. And when Uncle Sam asked citizens to ration food and gas, save scrap metal, grow victory gardens, and buy savings bonds, Yakimans responded enthusiastically.

After World War II, Yakima continued its excellence in agriculture, especially orchard fruits. Hops, used in beer, were also becoming an important economic crop. In fact, the Yakima Valley would eventually be home to 75 percent of the country's hop production and, along with the Wenatchee and Okanogan Valleys, home to 30 percent of the country's apple production. The Yakima Firing Center would remain after the war, providing a long-term training facility for regular and reserve armed forces. The J.M. Perry Institute expanded its curriculum to respond to post-war needs.

Yakima isn't all about hard work. Several well known celebrities have come from the valley. Brothers Steve and Phil Mahre took multiple medals in the Winter Olympics for skiing. Mel Stottlemyre has made a name for himself in major league baseball, as has his son Todd. Floyd Paxton, inventor of the Kwik-Lok plastic lock, built a factory in Yakima to make those little disks that make sure your bread stays fresh. Debbie Macomber, best-selling romance author, is also from Yakima.

In more recent years, grape production and wineries have been adding to the county's growth. The first winery within the city limits opened just recently. Other brewpubs have opened in the downtown area. Many of the major retailers have moved out of the cramped downtown seeking the wide open spaces on the outskirts, so city fathers hope to rejuvenate the downtown by creating an entertainment district. The brewpubs, antique stores, and cafes are a good start. The Capitol Theater will play a pivotal role in the rejuvenated downtown.

Excellent weather, a diversified economic base, a colorful history, and many educational and cultural opportunities make Yakima a wonderful place to live.

One
THE EARLY DAYS

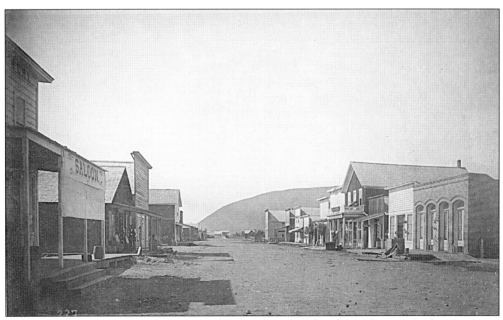

In 1884, Yakima City sported at least one main street, lined with buildings on both sides. Main Street was lined with livery, saloons, general merchandise stores, and other businesses essential to a town based on horse-based transportation and a farming economy. The two-story building in the right foreground is the Gervais store. The tall building at the right side at the end of the street is Centennial Hall, built in 1876. This area became part of Union Gap, after 1918.

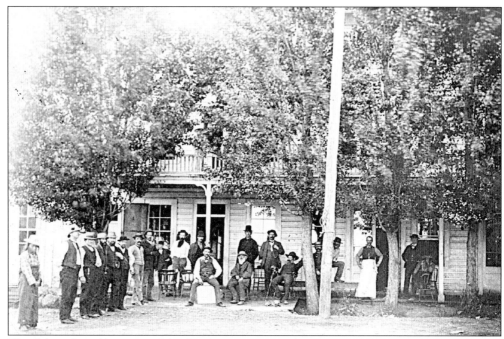

The Adams Hotel was one of the first businesses in Yakima City in 1884. Evidently this hotel was one of the few businesses that elected not to move to North Yakima, after the railroad located its depot there.

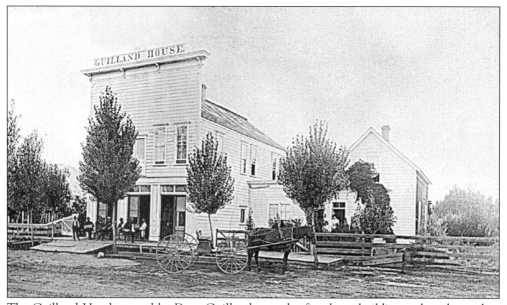

The Guilland Hotel, owned by Dave Guilland, was the first large building to be relocated to North Yakima. This picture of the hotel shows it in its original location in Yakima City. In February 1885, the railroad groomed a special track for the hotel and other large buildings. It took a month to move the hotel four miles. During that time, customers still stayed overnight in the rooms and received their meals even while the building was in motion. Its new home was on S. 1st Street.

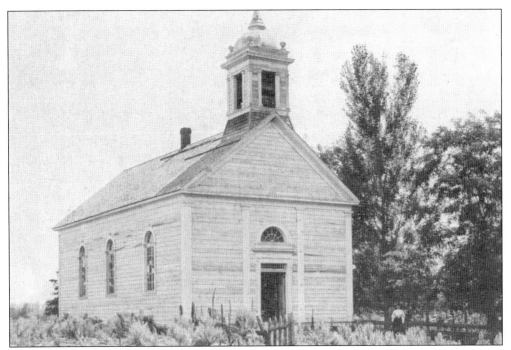

St. Joseph's Catholic Church was one of many buildings that moved from Yakima City to North Yakima. This picture shows it at its original location, remote and surrounded by sagebrush. After moving, the church was dedicated on December 8, 1886, at its new location. The congregation soon outgrew its quarters, leading to construction of a new building.

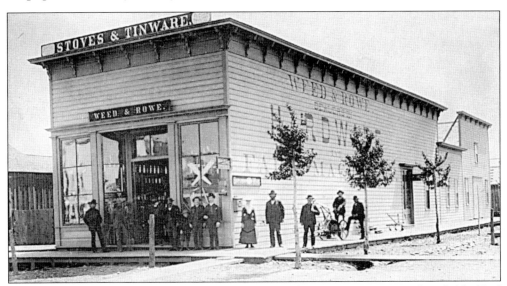

The Weed & Rowe Hardware Store first opened in Yakima City in 1881, co-founded by Fred Imbrie and H.S. Rowe. Imbrie later sold his interest to A.B. Weed. This picture was taken in 1886, shortly after the store had been moved from Yakima City to North Yakima, at the corner of S. 1st Street and Yakima Avenue. The store contained 2,100 square feet. By the 1950s, the store now known as Yakima Hardware occupied almost 130,000 square feet of retail and warehouse space.

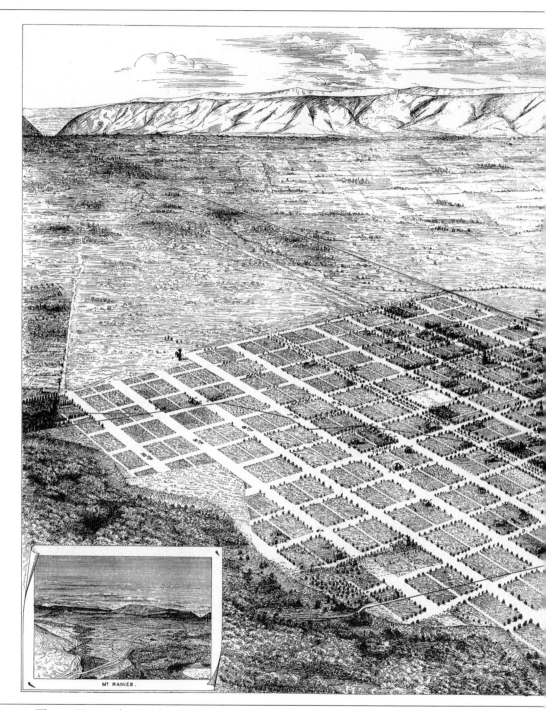

MT RANIER.

This 1889 map depicts the new city of North Yakima. It had grown up at this location since its move in 1884 from its original location four miles south. This view looks north to south; the Yakima River is out of view to the right of the picture. In just four short years after relocation, the city was booming and many residences were located throughout the town. The railroad transects the city, north to south. Many other city blocks had already been platted and streets

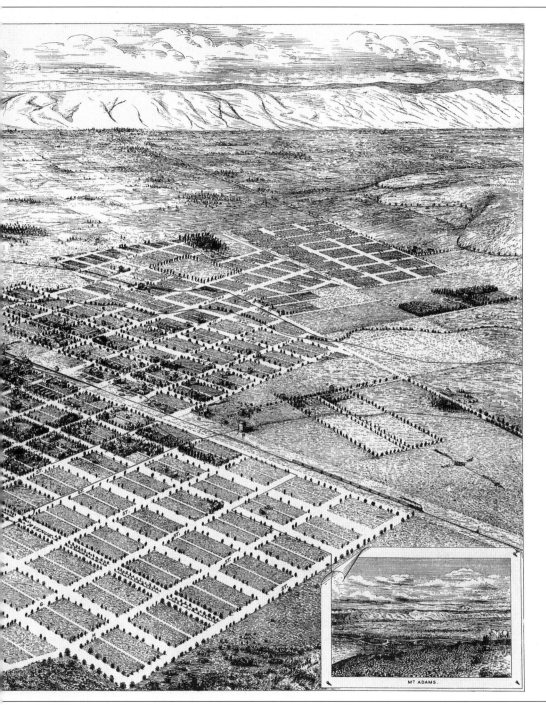

MT ADAMS.

graded. There were five churches, a courthouse, six real estate offices, two newspapers, two shoe stores, two banks, and many other businesses. These types of panoramic maps were very popular items during the last decade of the 20th century. This particular map, made by the Spike and Arnold Map Publishing Company, was originally printed in 1889.

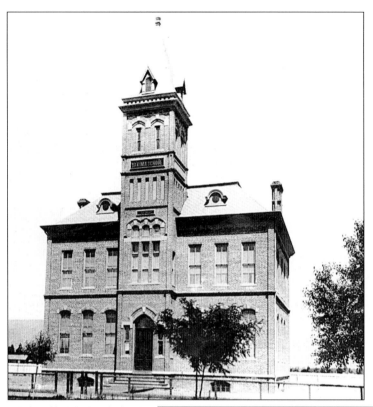

The Central School, built in 1888 at 217 S. 2nd Avenue, was the first high school built in North Yakima. A.F. Switzer built the school on land purchased from the Northern Pacific Railroad. In 1894, the school was remodeled to accommodate all the students from Columbia School so all high school age students would be in one building. In 1898, a fire escape was added to the exterior. In 1924, the building was condemned and torn down.

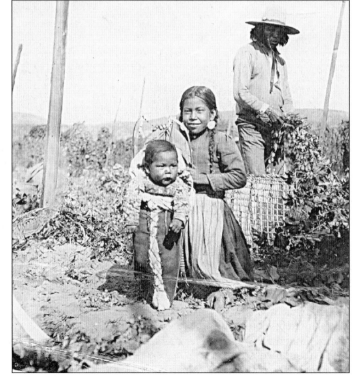

Yakama Indians from the local reservation supplied much of the labor for picking crops. One early account speaks of the early state fairs and how the horse racing was postponed until the Yakamas could join them after the harvesting was complete. This small family is one of many that picked hops in the valley.

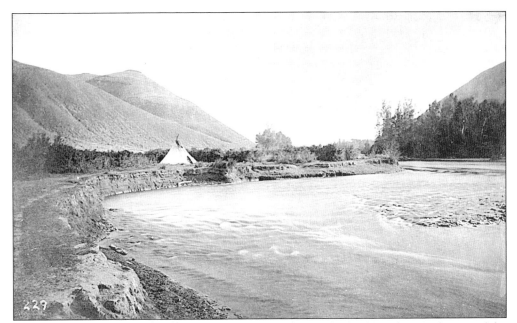

This Indian tepee stood near the original Yakima City in 1890, and stands near the site of the first battle of the Indian Wars of 1855–56 near Ahtanum Ridge. The skirmish was known as the Battle of Two Buttes. The Daughters of the American Revolution erected a monument to the battle at this location in 1917. The Yakama Indians erected another monument later.

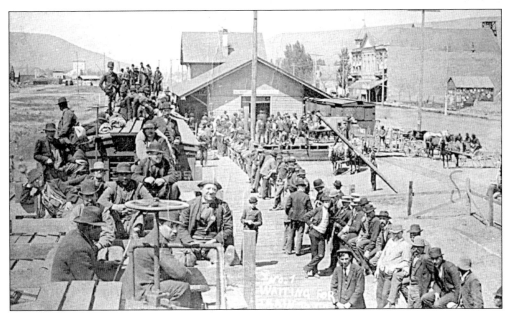

Unemployment was high across the country following the 1893 depression. President Cleveland refused to provide government relief for the unemployed. Supporters of Jacob Coxey formed around the country, prepared to lay siege to the White House until their demands were met. This group of Coxey's Army passed through Yakima on their march in 1894. A riot broke out among the protesters and the lawmen, but fortunately there were no serious injuries.

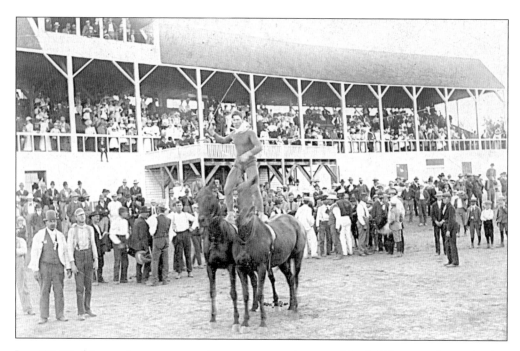

In 1889, Washington became a state. The race was on between North Yakima and several other cities to become the state capitol. It took two votes before Olympia was selected as the capitol. Instead North Yakima received the state fair, of which the first was held in 1894. This large grandstand was built at the fairgrounds off Nob Hill Boulevard. Despite what looks like a huge turnout, the fair did not make enough money to repeat the event the following year. Instead, the Yakima Commercial Club organized a citizens' fair. The highlight was the Indian dance shown below, with several chiefs of the Yakama Indians in attendance. The fair was held again in 1896, and horse racing continued to be one of the most popular events.

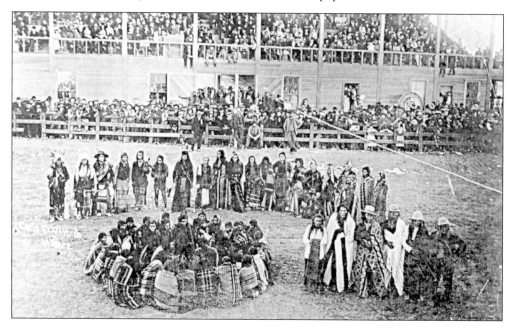

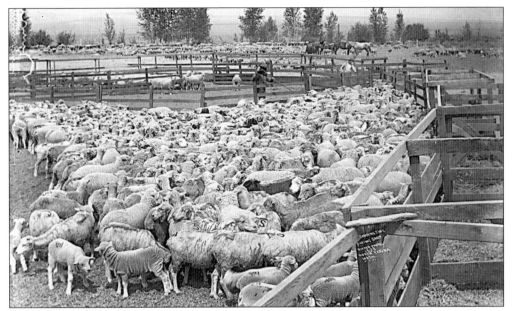

Augustan Clemen brought the first sheep to the Yakima Valley in 1865. He found the area to have good fields for grazing. Most of the early sheepmen were English or Scottish, but there were also some Spanish Basques. Flocks grazed in the hill of W. Yakima Avenue and in Terrace Heights. The business kept hundreds of people employed. Here at the T.H. Smith ranch, sheep are kept in holding pens and sorted for shearing.

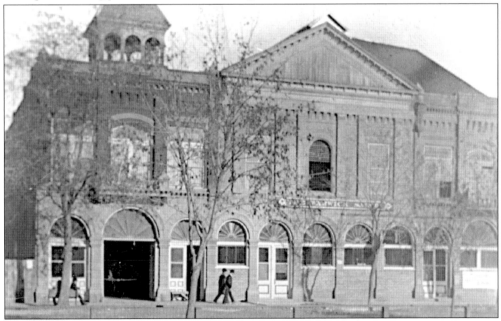

The Switzer Opera House was built in 1889 at 25 N. Front Street. At the beginning, the opera house seated 300 people. The theater was on the second floor, and had three sets, consisting of a parlor, a kitchen, and a garden. The theater was lit by kerosene lamps and heated with two stoves. *Uncle Tom's Cabin* and *My Old Kentucky Home* were popular early shows. The opera house didn't last and closed by 1900, about the time this photo was taken.

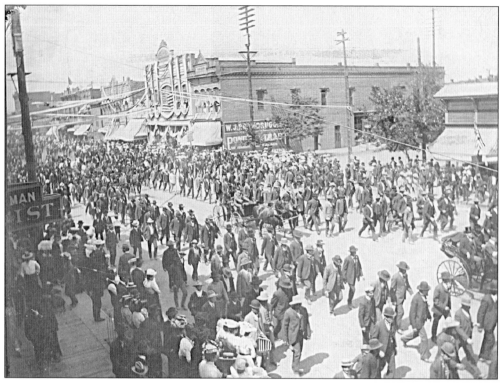

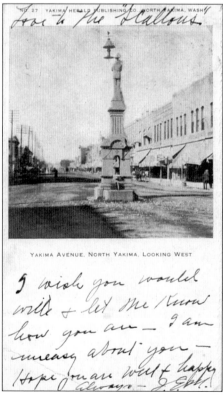

To celebrate the first Memorial Day of the new century, the city held its annual parade. These Civil War veterans marched proudly down 2nd Street. Large crowds followed the soldiers to the cemetery to pay their respects. Also in the parade were soldiers who fought in the Philippines. The Women's Relief Corps was also represented. After the graveside ceremonies, the soldiers proceeded to Mason's Opera House for a patriotic program, where the crowd sang "America."

The Weisenberger Monument was dedicated on the corner of E. Yakima Avenue and S. 3rd Street on July 4, 1902. The statue, along with its drinking fountain and watering trough, commemorated John J. Weisenberger and Company E, who fought in the Spanish-American War. The monument was moved to the new courthouse property in 1908, and moved again when the courthouse was rebuilt on Naches and Yakima Avenues.

Two
YAKIMA GROWS

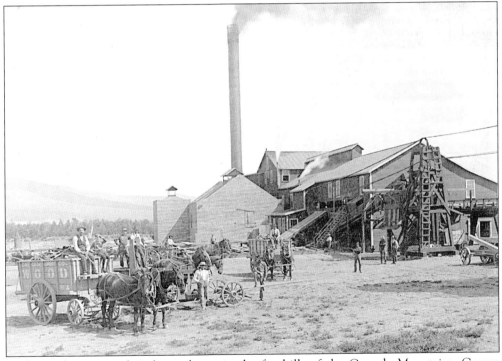

Realizing the potential timber industry in the foothills of the Cascade Mountains, George Rankin built a mill in North Yakima in 1902. The Yakima and Teanaway Rivers were used to float the logs to the mill. This picture was taken in 1904, after two seasons of successful harvesting. The Cascade Lumber Company survived the Great Depression, both World Wars, and numerous disastrous floods. In 1951, it merged with Boise-Payette to become Boise Cascade Corporation, which is still in business today.

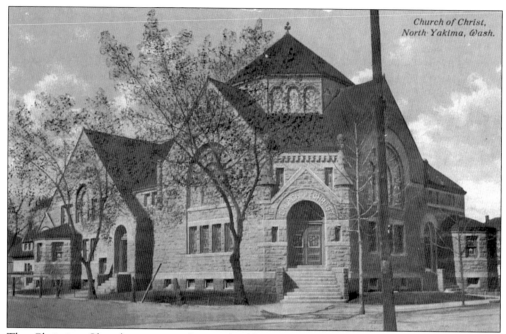

Church of Christ,
North Yakima, Wash.

The Christian Church was one of many buildings that moved from Yakima City to North Yakima. The original wood structure stood at N. 3rd Street. This new building was erected in 1908 at 3rd and B Streets. An education facility was added in 1926. The congregation also established a sister church on the Yakama Indian Reservation at White Swan. This building still stands at 3rd and B Streets, near the Yakima Valley Regional Library.

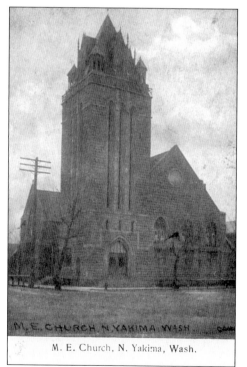

M. E. Church, N. Yakima, Wash.

Land at the corner of N. 4th and E. A Streets was purchased from Henry Scudder for the new Methodist Church. Construction was completed in 1905, for $40,000. In 1924, the church moved one block east to Naches and A Streets. The Stone Church of Assembly of God took over the original structure. In 1968, both buildings were sold and the churches moved to new locations. The Yakima Mall now stands in this location.

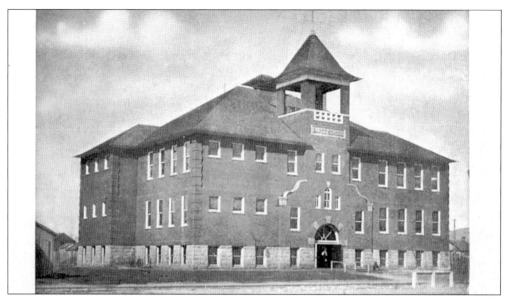

The Barge School, located at N. Naches Avenue and E Street, was completed in 1905, and was designed by N.C. Ganutt. The school was named for Professor B.F. Barge, an early teacher and the first president of Central Washington College in Ellensburg. In 1959, the school was condemned as a fire hazard. In 1960, the school was torn down, after saving the 300-pound school bell and the cornerstone to be installed in the new Lincoln School.

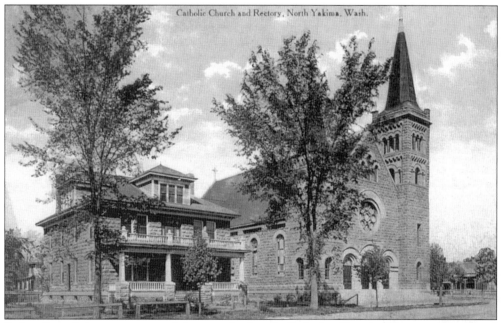

Father Feusi led construction of the new St. Joseph Catholic Church. The new church and rectory were built entirely of basalt, with Roman architecture used throughout. The church was formally dedicated in January 1906. In 1955, several improvements in the church included a new Wurlitzer organ, better lighting, restoration of frescoes, and addition of new roof, gutters, and steeple.

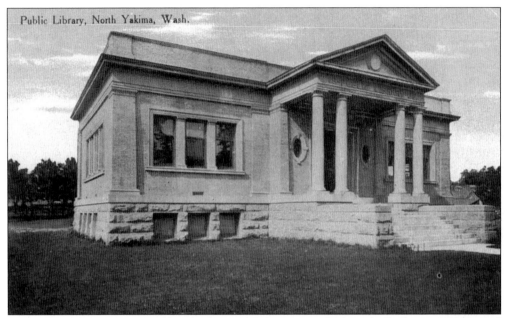

Public Library, North Yakima, Wash.

This public library was one of hundreds around the country built with funds supplied by steel magnate Andrew Carnegie. The building was dedicated in 1906 and opened in 1907 at N. 3rd and A Streets. In 1944, a county library district formed and grew to 12 branches. By 1956, the old library had grown too small. A new library opened on January 17, 1959, in approximately the same location.

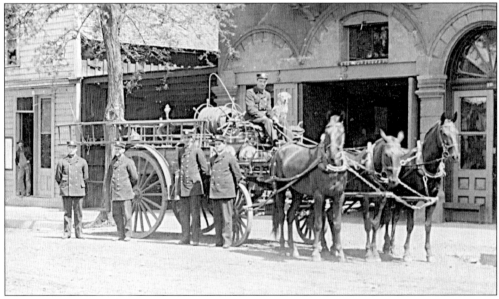

The year 1906 was the first year that Yakima had a full-time, paid fire department. In this picture, the crew shows off their new horse-drawn fire engine in front of the Front Street station. The unit was kept busy in May, when a fire started in the courthouse and destroyed fourteen other buildings and several railroad cars. In 1912, the department sold its last horse-drawn engine and completely mechanized, the first department west of the Mississippi to do so.

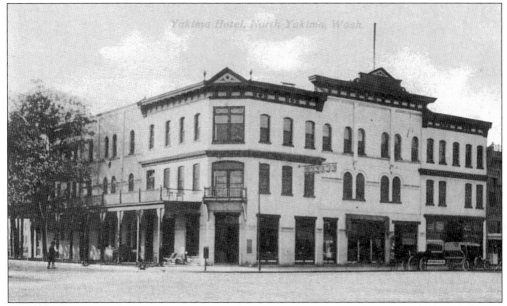

The Yakima Hotel, located at 3rd Street and E. Yakima Avenue, opened on July 4, 1889. The parlor had an upright Kimball piano and Brussels rugs graced the floors. It had a two-story veranda and outdoor plumbing. The first telephone exchange was in the lobby of the hotel. Norval and Bertha Johnson added a third floor and modern plumbing in 1900 and the building became known as the Hotel Yakima.

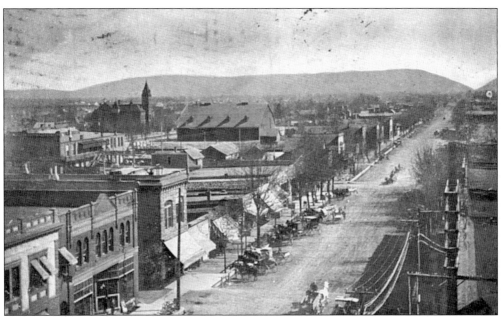

In this picture of Front Street, the streets are all still unpaved in 1907. Quagmires during rainfall prompted the city to pass an ordinance in 1908 that would facilitate paving the main streets. The railroad depot is on the right edge of the picture. Central School is the tall building in the left distance. The foreground is filled with various general merchandise stores and other businesses.

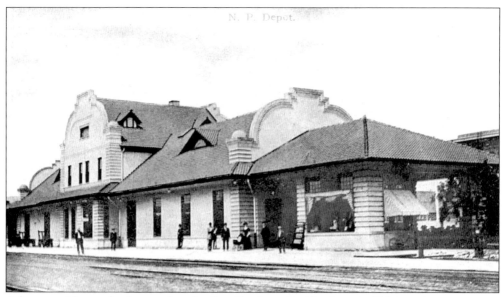

A boxcar without wheels served as the first Northern Pacific depot in Yakima. A new wooden depot was built in 1886. Due to the amount of business, a new depot was needed. This depot, designed by Cass Gilbert, was built in 1909–10. The original wooden structure was sold for $100, and moved to N. 1st Street. The new depot opened in May 1910. Today the old building hosts several shops.

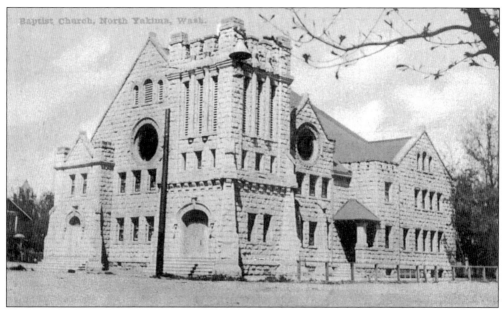

Baptist Church, North Yakima, Wash.

The first Baptist Church was a wooden structure built at 4th Street and Yakima Avenue, in 1892. A parsonage was built next door. This is the second church, located at 6th Street and Yakima Avenue. The cornerstone was laid on May 2, 1908. It was dedicated on January 10, 1909. The cost of the building was approximately $40,000. In 1948, a school was added, and in 1958 more seats and basement classrooms were added. The church is still in use today.

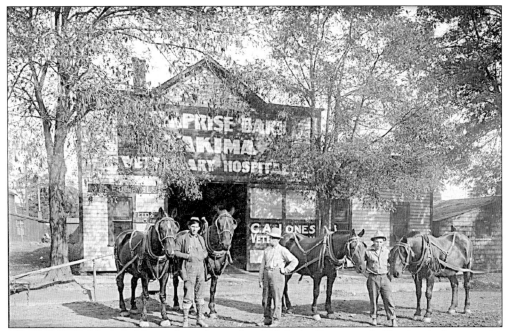

The Yakima Veterinary Hospital was located at 209 S. 1st Street, with Charles A. Jones as the veterinarian. This picture was taken about 1909, when horses still outnumbered cars on the streets. In 1917, Jones formed a partnership with Robert Prior and changed the name of his business to the Washington Veterinary Hospital. In 1918, Jones formed a new partnership with a man named Mackintosh. The hospital eventually closed in 1939.

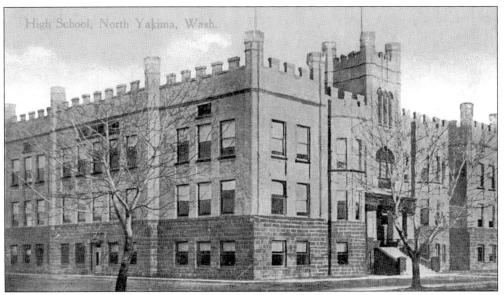

In 1907, a disastrous fire burned down the Lincoln School, where high school had been held since 1900. High school was held in the Methodist Church until this new building was completed on 212 S. 6th Avenue. North Yakima High School was opened in 1908. When completed, the school cost just $120,000. The building had 23 classrooms for 690 students. In 1917, an athletic field, 15 new classrooms, and a gymnasium were added.

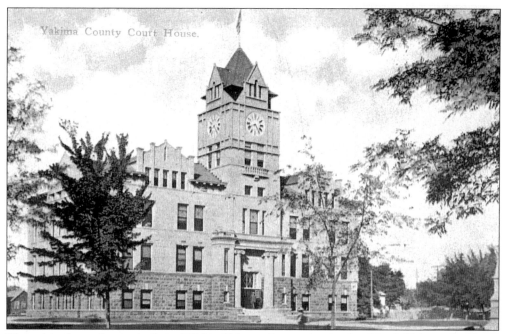

The original courthouse, built in 1884 in Yakima City and moved to North Yakima, had been destroyed by fire on May 5, 1906. The cornerstone was laid for the new Yakima County Courthouse on June 5, 1906. Over 1,000 people attended the ceremony. Built by Bill Yeaman, the new courthouse was built of stone just north of the old building. Construction was completed in 1909. A new courthouse was built in 1960 and still stands today.

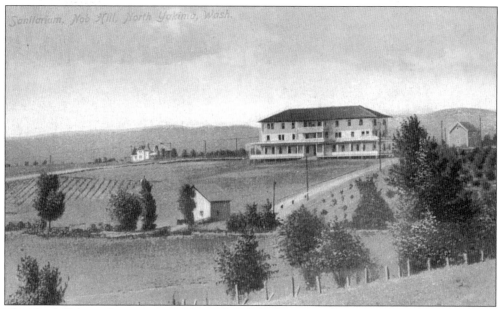

The North Yakima Sanitarium was located at S. 24th Avenue between W. Chestnut and Nob Hill Boulevard. Doctor and surgeon Frederick M. Rossiter was the medical superintendent of the sanitarium. He also had a private practice downtown at the Miller Building. The sanitarium was a short-lived Yakima landmark, lasting from just 1907 to 1910.

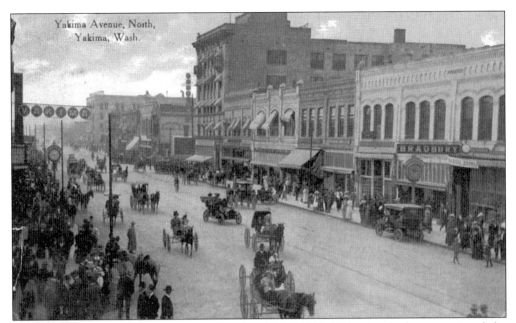

This picture of East Yakima Avenue was taken about 1910. This view looks west, toward the always-dominating Miller Building. In the right foreground is the Bradbury Company, whose photographers contributed to preserving the history of the city in pictures. The clock on the left side of the street belongs to Dunbar Jewelers, a relic that the business still displays today. Also of interest are the varying types of horse-drawn conveyances.

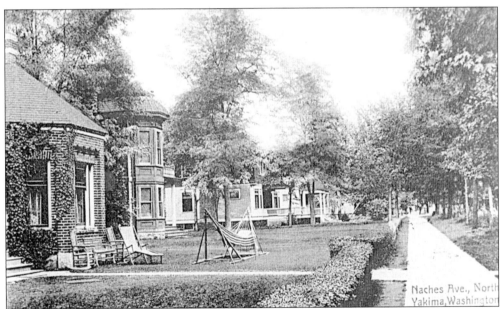

Naches Ave., North
Yakima, Washington

These homes line the east and west sides of Naches Avenue, c. 1910. The street had been asphalted just two years before. Many of these homes still stand today, though some have been converted into apartments. This street is the only street in Yakima that is divided by a grassy meridian, giving the street a park-like setting. When it was initially built, city officials even brought in squirrels to add to the atmosphere.

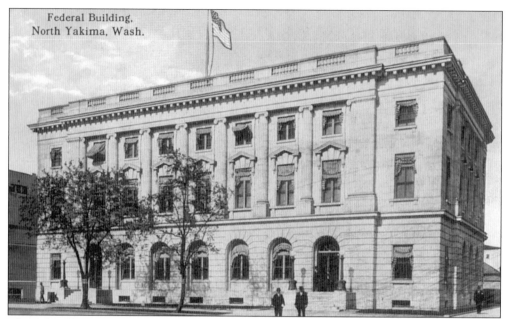

This federal building housed the post office when it was first opened. It was completed in 1911 at Chestnut and 3rd Streets. The Federal Court and U.S. Department of Justice occupied the second floor. The Bureau of Reclamation and other government offices occupied the third floor. On October 27, 1978, the building was renamed the William O. Douglas Federal Building to honor the retired Supreme Court Justice.

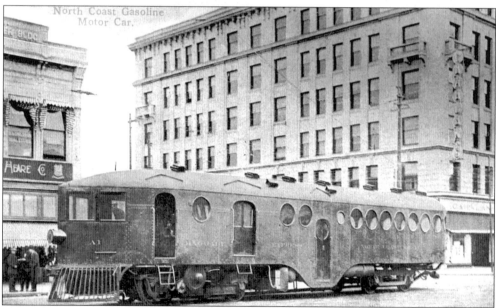

Robert Strahorn began construction on the North Coast Railroad in 1907, and the line was completed in 1911. This McKeen gasoline-mechanical car was capable of speeds of up to 60 miles per hour. The car could carry 65 passengers and their luggage, plus freight. Use of such cars was limited, however, since they had difficulty negotiating certain turns. They were used almost exclusively on the Wiley City line and as transportation between Yakima and other towns.

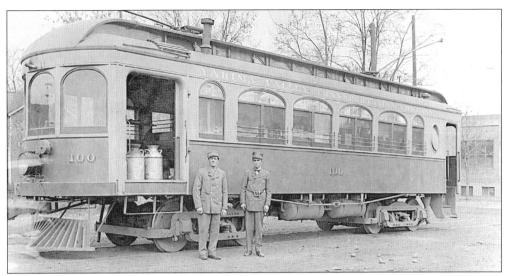

The Yakima Valley Transportation Company broke ground for its electric trolley line on September 9, 1907. The company built a depot at 1st and B Streets and a maintenance shop at 3rd Avenue and Pine Street. Car No.100, built in 1909 by the Niles Car & Manufacturing Company, is typical of the many types of trolleys used. The car was 45 feet long and could carry 38 passengers, and was also capable of carrying baggage. It was scrapped in 1947.

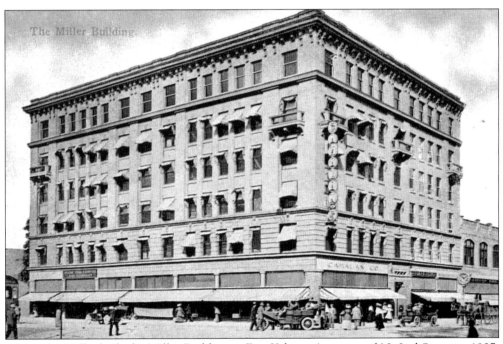

Alexander Miller built the Miller Building at East Yakima Avenue and N. 2nd Street in 1907. With five stories, it was the largest office building in the city, with space for 45 offices. The Calahan Co., a dry goods store, the Yakima Real Estate Company, architect W.W. DeVeaux, and several doctors and attorneys also rented space. Another floor and a new wing were added in 1911. Frederick Mercy purchased the building in 1946.

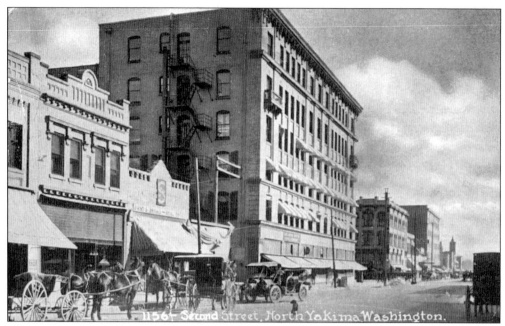

This view of North Yakima looks down E. 2nd Street towards the south. The Miller Building predominates the center. To the left is the Dash and Briggs Real Estate Office. Central School is in the far distance. This picture was often used in postcards and news articles about the city. Some editions were erroneously labeled 3rd Street. The photo dates from 1912.

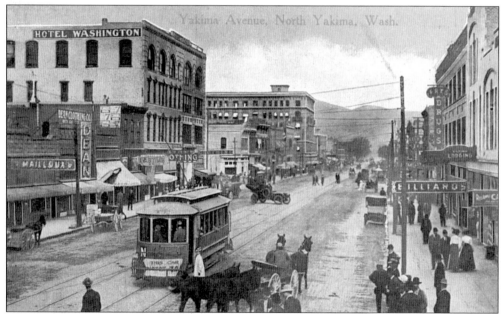

This view looks east down Yakima Avenue, at about Front Street. Hotel Washington sits at East Yakima Avenue and N. 1st Street. In the center distance is the Miller Building. By now the heart of Yakima is lined with clothing stores, restaurants, and even a billiard room. This picture is especially interesting because it shows horse-drawn vehicles, an electric trolley, and an automobile, all in use during the same time period.

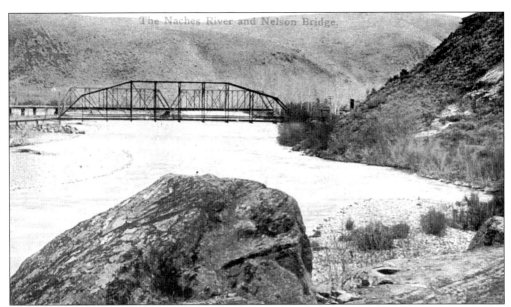

The Nelson Bridge over the Naches River was named for John B. Nelson, an early settler of Yakima. He built one of the earliest irrigation ditches in the area. In 1864, the Nelson family settled near the mouth of the Yakima River before moving to the Naches River. A big flood in 1867 prompted him to move farther from the river. This picture shows the Naches were it empties into the Yakima, and the bridge that was named for a Yakima pioneer.

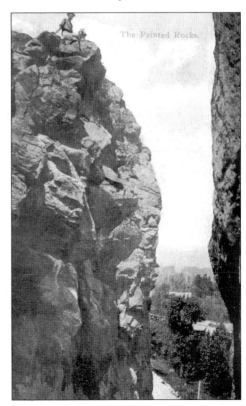

The Painted Rocks.

Just off Highway 12, on Powerhouse Road, lie some mysterious ancient pictographs. The "Painted Rocks," as they became to known to Yakimans, may be thousands of years old. Even modern Indian tribes do not know the origin of these markings. The markings cover the face of these ancient lava flows, which cooled slowly and formed jointed "columnar" basalt formations. Today the markings are protected and marked as a roadside attraction.

31

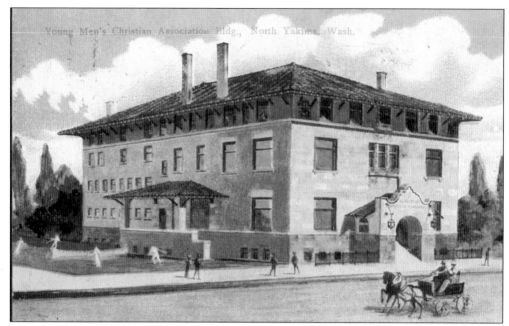

In 1906, a steering committee collected donations to build a YMCA. James H. Fraser sold a lot on S. 4th Street for the building. A groundbreaking ceremony was held on March 4, 1907. The YMCA opened on September 1, 1908. In 1935, the building was remodeled to replace the gym with handball courts and the swimming pool was closed. In 1958, the YMCA moved to a new building on Naches Avenue and Yakima Avenue.

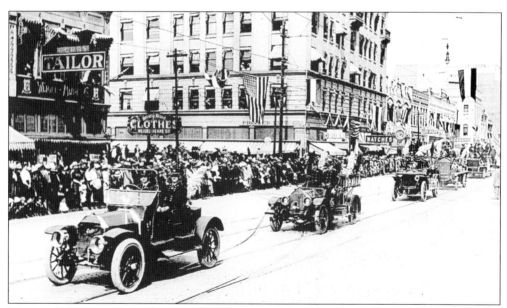

The Apple Blossom Festival was celebrated on April 5, 1913. The celebration was a big event throughout the Northwest and even schoolchildren were dismissed for the day. A huge parade ran down Yakima Avenue, celebrating the bountiful harvest of the valley. An apple dance was also held at the Commercial Club, and hotels and restaurants served special dishes that featured apples. The Yakima Hotel printed a special menu with apples printed on the pages.

Lenora Draudt married James Rooney Sr. on Wednesday, June 25, 1913 at St. Joseph Church at 8 a.m. In those days, the Catholic Church did not perform weddings past noon on any given day. Can you imagine a modern bride coping with a wedding at 8 o'clock in the morning? The couple lived on 11th Avenue, and then later 12th Avenue. James Rooney was one of many workers who helped build Franklin Park, where today's Franklin Middle School, Franklin Swimming Pool, and the Yakima County Museum are located.

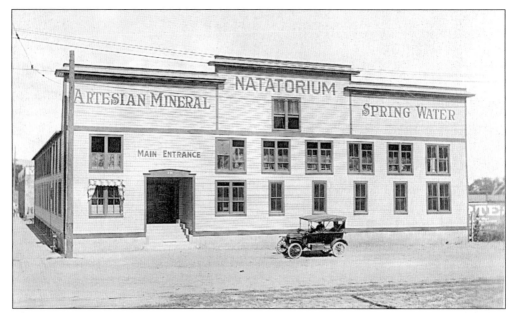

The natatorium, completed in 1911, was located at 201 S. 6th Avenue. It offered swimming, diving, and bathing. The heat from the steam was piped into tunnels to heat houses. The natatorium provided distilled water for batteries and delivered artesian water. It was on the regular route of the electric trolley cars. The business shut down in 1938.

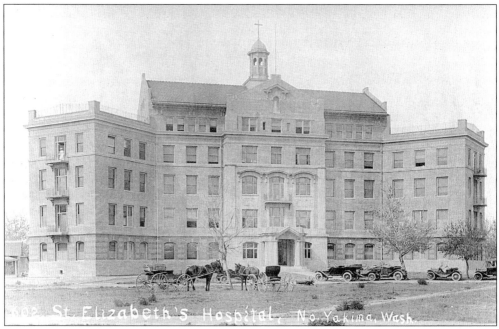

St. Elizabeth's Hospital was an impressive building when it was completed in 1914, a long way from its original 13-room, two-story house. The growing number of patients necessitated construction of this multi-story brick structure at 110 S. 9th Avenue. In 1945, a new wing was added. In danger of losing its accreditation, the hospital was completely remodeled in 1965. In 1979, it built a landing pad on the roof for a helicopter ambulance.

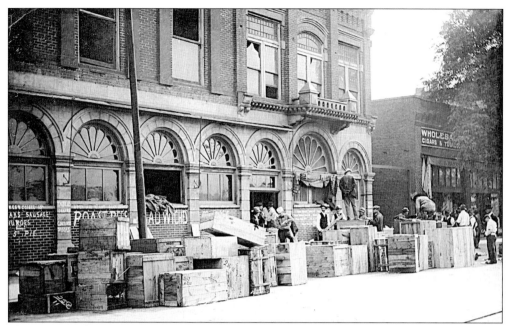

This picture taken about 1918 shows crews sorting goods to send overseas during World War I. The collection area is in front of the old Switzer Opera House on Front Street. At the time of the collection efforts, the brewing company that formerly occupied the space was closed due to Prohibition. After the war, Yakima Transfer & Storage Company occupied the building, but a brewery returned in 1982. Grant's Brew-Pub is known as the first of its kind in the U.S.

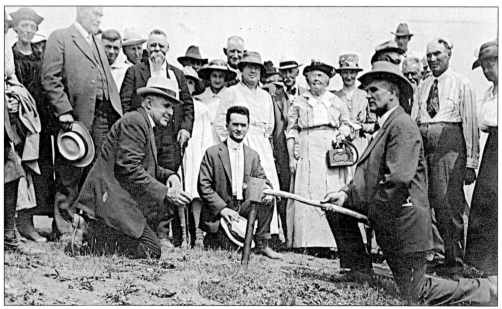

The Yakama Indians had always relied on seasonal hunting and gathering until Chief Kamiakin learned how to grow crops from seed. The missionaries also showed him how to channel water into a ditch for irrigation. This dedication ceremony on June 30, 1918, preserved the spot that Chief Kamiakin had used for his garden.

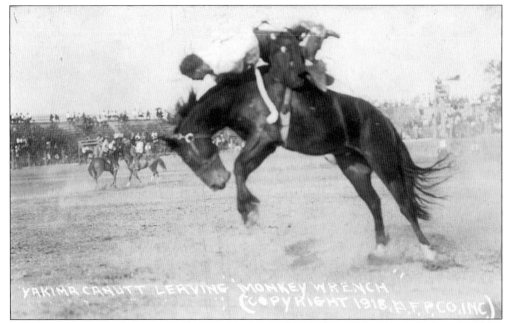

Yakima Cannutt may be the most famous person not from Yakima. Born Enos Cannutt in 1896, Yakima is actually from Colfax, Washington. He started riding in rodeos at age 16. This picture, from 1918, shows him riding one of his early conquests, Monkey Wrench. Though likely he appeared in Yakima during his many rodeo shows, it seems he did not ever live here. In 1924, he went on to Hollywood and became a famous stuntman in westerns.

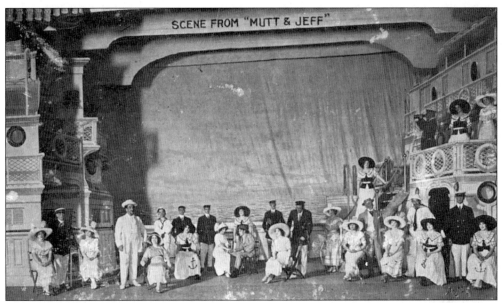

The Yakima Theater was located at 11 N. 2nd Street and A Street, opened on June 11, 1900. It was originally known as the Larson Theatre, built by A.E. Larson. It was first a performing theater and later a movie theater. This scene shows the cast of Mutt and Jeff in an early production. Frederick Mercy acquired the theater in 1916; however, the building became a fire hazard and was torn down in 1920.

Columbia School was built in 1890 on N. 4th Avenue for both elementary and high school children. It had two stories and a large bell tower. When strong winds blew the whole building rocked. Mrs. Ella Stair was a favorite teacher there for many years. Additions were built in 1899 and 1903. Columbia was one of the first to try the new fire escape tubes, a canvas tube attached to second floor windows to slide to the ground.

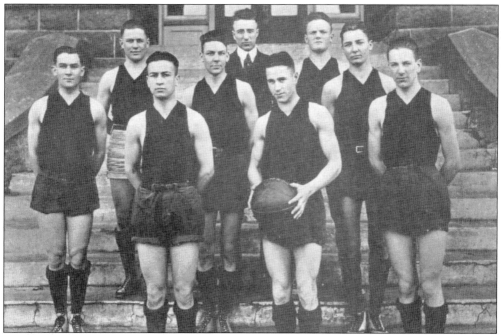

The Yakima High School boys' basketball team of 1922 had an exceptional year, outscoring their opponents 401 to 249. They only lost one conference game that year. From left to right are pictured: Fred Ball, John Robinson, James Bradford, John Young, Coach Shactler, William Vermilye, Harold Anderson, Arthur Smith, and Paul Miller.

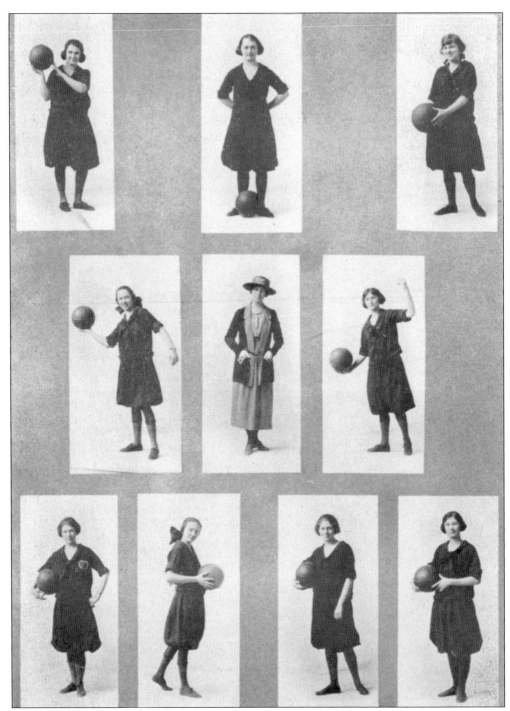

In 1917, when a new gymnasium was built for Yakima High School, it was the first time the girls assembled a basketball team. Pictured here is the 1922 girls' basketball team, left to right: (top to bottom) Bernita Wimer, Anna Louise Robinson, Mary Whitmore, Martha McAulay, Coach Tenneson, Catharyn McCurdy, Dorothy Tucker, Carrie McAnally, Gladys Gue, and Pauline McWilliams. The girls won 8 out of 10 games.

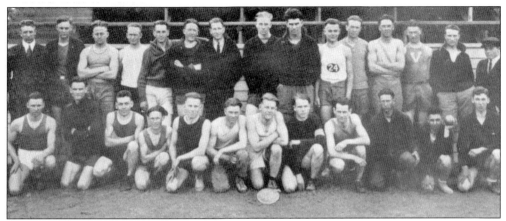

Yakima High's 1922 track team consisted of the following boys, left to right: (front row) Thurber, Schlosstein, Joe Groenig, Wilson, Gans, Campbell, Perry, Butler, Peaslee, Whitaker, Hatch, and Lynch; (back row) Coach Roy Shactler, Reese, Creamer, N. Messer, John Groenig, Edwards, Leslie, Gronvold, Dixon, Rosenkranz, White, Crabb, McCowan, Dills, and Neilan (manager). Gronvold achieved a new state record by throwing the shot put 125 feet, 3 inches.

Pictured is the 1922 Yakima High debate team, left to right: (top) Margaret Trout and Lorna Defoe; (bottom) Wayland Chase and Waldo Gedosch. In the center is their coach William O. Douglas, who would later become famous as a Supreme Court judge. Gedosch served as the team's manager. The team won the Inland Empire Debate Championship by conquering Walla Walla, Lewis and Clark, Wenatchee, and Colville.

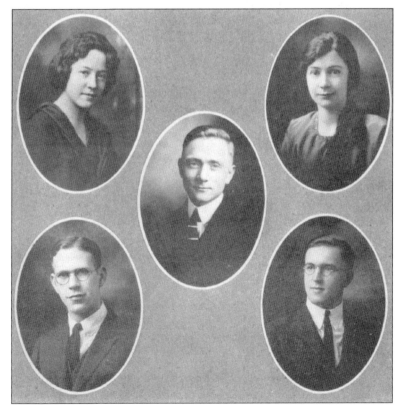

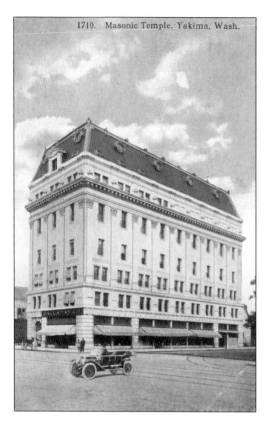

1710. Masonic Temple, Yakima, Wash.

The Masonic Temple was built on N. 4th Street and E. Yakima Avenue. Ground was broken on September 10, 1910, with many Masonic dignitaries on hand. The building, which cost approximately $200,000, was completed in November 1911. A year or two later, John J. Callahan moved his business from the Miller building to the ground floor of the temple building. The building is now called the Great Western Building.

Angus C. Davis was the principal of North Yakima High School from 1909 to 1913 and superintendent of the Yakima School District from 1913 to 1947. This picture is from the 1923 yearbook. Davis had tremendous impact on the school system, expanding its curriculum and its facilities. Along with Elizabeth Prior he helped establish the valley's first two-year college in 1928. In 1957, the school board renamed the school Davis High School, after Davis.

In 1923, it was a challenge for the Yakima High School basketball team to do well, since all but two of the previous year's team graduated. But they persevered, winning five of eight games in district play, then easily taking the district championship. They went on to the state tournament and placed fifth in the state. Guard John Robinson was picked for the all-state team.

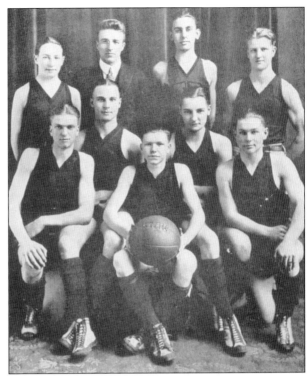

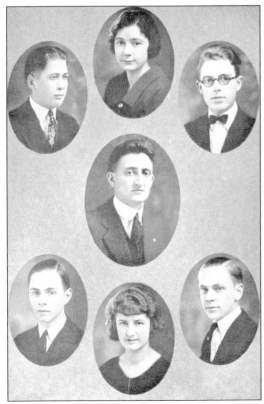

In 1923, Yakima High School had two debate teams. Mr. Sloan (center) led the team this year, as William Douglas left to study back east. Kendall Chase, Lorna DeFoe, and Paul Soper (top row) debated in the Inland Empire League. Eugene Klise, Ruth Quigley, and Howard Manning (bottom row) debated in the State League. Though the teams didn't do as well as the previous year they still tied for second, and third, respectively.

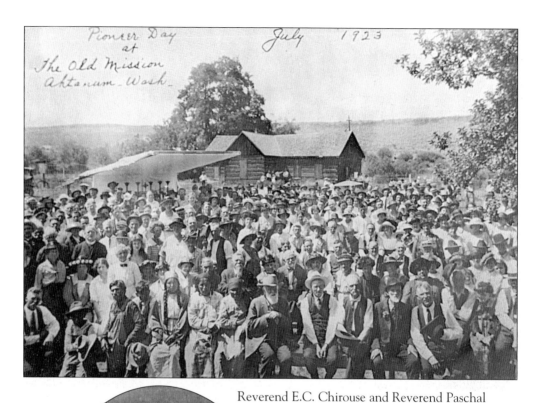

Pioneer Day at The Old Mission Ahtanum-Wash. July 1923

Reverend E.C. Chirouse and Reverend Paschal Picard founded Ahtanum Mission on Ahtanum Creek in 1853. The mission was destroyed by soldiers during the Indian Wars of 1855–56, when they suspected the missionaries were helping the Indians. This picture was taken for Pioneer Days in 1923, to dedicate a monument at the original mission site. Kiam Pum Sappallel, a Yakama woman estimated to be 100 years old, spoke at the event.

Elizabeth Prior spent 30 years in the Yakima School district, both as teacher and as assistant principal at Yakima High School. But her legacy is Yakima Valley Community College. The school, established in 1928, survived the Depression thanks to many instructors, who did without adequate supplies or books. Miss Prior managed the institution, campaigned for scholarship money, and still found time to advise students. She also taught journalism. One of the buildings is named after her.

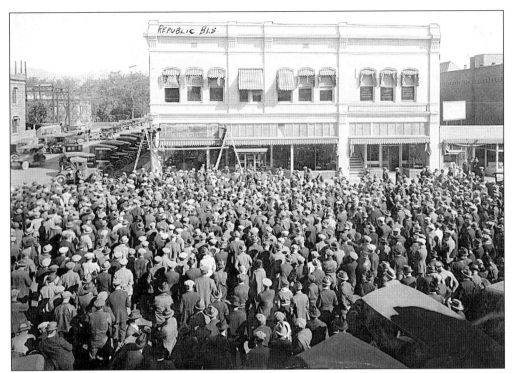

The *Yakima Record* was the first newspaper to be published in the valley, in 1879. The *Signal*, the *Republican*, the *Herald*, and the *Washington Farmer* soon followed. Multiple papers were published until 1912, when W.W. Robertson merged two papers to become the *Herald-Republic*. The building was located on N. 2nd Street. These people stand outside the newspaper office, listening to the World Series, in 1924. The Washington Senators won that year.

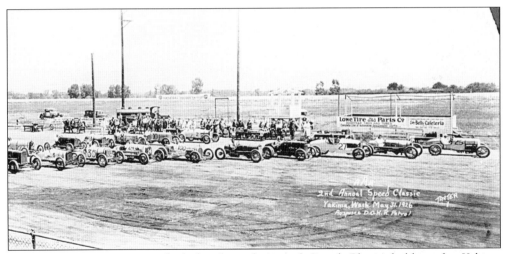

About 7,500 spectators watched the Second Annual Speed Classic held at the Yakima Fairgrounds on May 31, 1926. Jack Ross drove his Buttera Special to win three races. Former Yakiman Tony Grytting won the third event. Sadly, during that race one car crashed through a fence killing two spectators. Afterward, crowds gathered around these fences to avoid paying admission, at risk to themselves.

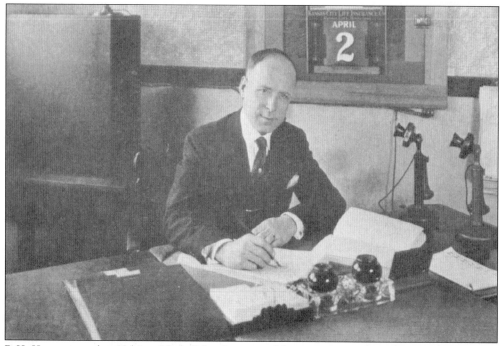

R.K. Kester served as Yakima High School principal for many years. Here he is in his office at the school. Note the old-fashioned quill pen and ink wells that were still in use. See also that he has two pre-dial telephones on his desk. However, his desk calendar looks very much like those still in use today.

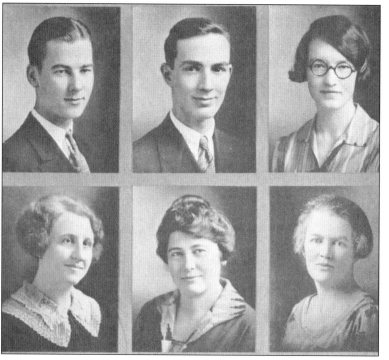

These students and their faculty advisors were instrumental in publishing the annual yearbook, called the *Lolomi*, a Native American word that means "peace." At top, left to right, are Allen Winkelman, editor; Lewis Humphrey, manager; and Katherine Hunt, art editor. Pictured at the bottom, left to right, are Elsie Hartmann, Irma Zickler, and Helen Collins, faculty advisors.

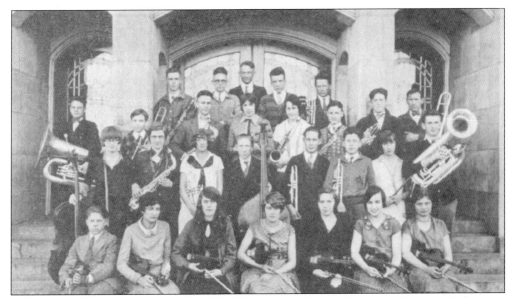

The Yakima High orchestra of 1927 ended the year with a much improved and well-rounded group. Though the orchestra lost many graduating seniors, other members stepped up to the plate and filled leadership roles. Music teacher Mr. D.R. Canfield was quite pleased with the group's progress. Included in the group were violins, cornets, clarinets, flute, saxophone, trombones, viola, euphonium, tuba, bass viol, and drums.

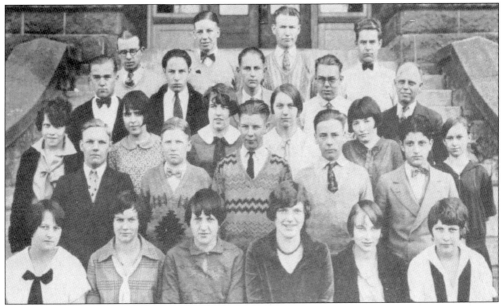

Did the class of 1927 have a premonition of what would befall the country in just two short years? This class organized a thrift committee, to teach students the importance of saving and spending wisely. One representative from each homeroom was a member of the committee. A school savings bank was established and by the end of the year over half of the students had accumulated savings. The following year, the percentage rose to 85 percent!

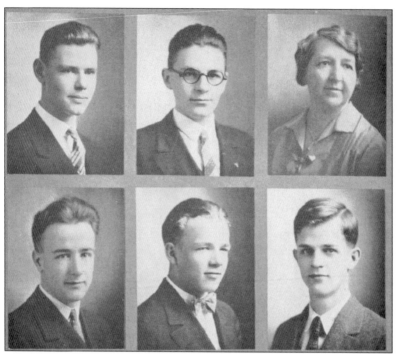

The drama club of 1927 put on many fine performances during the year, including Shakespeare's *As You Like It*. Pictured in the top row, from left to right, are Paul Allen, Marvin Armstrong, and faculty advisor Jessica Reed. In the bottom row, from left to right, are Athol Durrell, Robert Dryer, and William Dingle.

Pictured is John Reese, c. 1928. After learning the ropes at Thompson Bakers Inc. and Twin Bakery, Reese spent a long career as a baker for Snyder's Bread. Snyder's has been a part of the Yakima scenery since 1929. The bakery is still in business on 3rd Avenue and distributes bakery goods throughout the Pacific Northwest.

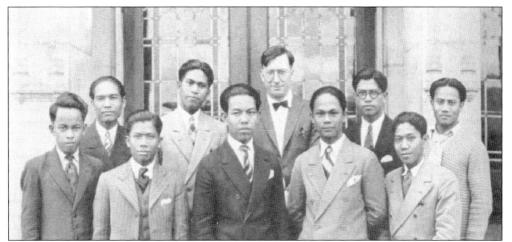

Faculty advisor Mr. P. Sparks championed the Filipino Club at Yakima High School in 1928. The purpose of the club was to establish a "firm, friendly relation between the Filipino students and the faculty." This club joined with a similar club in Wapato and sponsored a celebration to honor Filipino national hero, Dr. Rizal. In addition to regular meetings the club also subscribed to the *Philippine Republic Magazine* for library circulation.

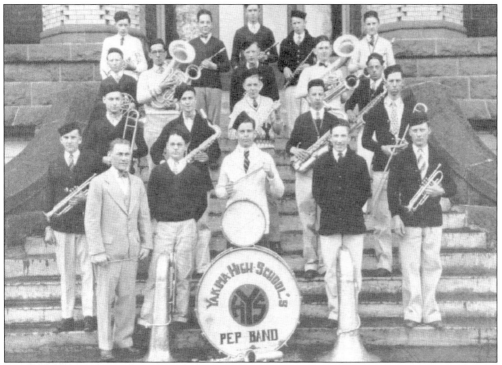

The year 1928 marked the first year that the Yakima High School pep band rehearsed daily. They were also lucky enough to acquire A.H. Olsen, who was the student director of the University of Washington band. The band played at each home football and basketball game, as well as provided music for assemblies and rallies. On April 27, the band participated in a concert given by the orchestra and glee clubs.

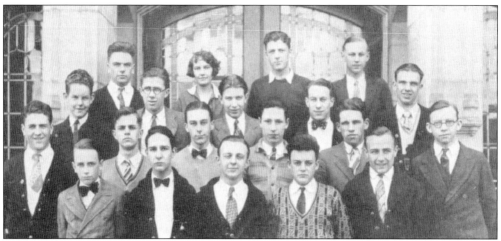

In 1928, the Boys' Glee Club sang for several occasions, including a music assembly, two debates, and the mid-year graduation ceremony. Two subgroups consisting of a quartette and double quartette were formed from the main group. They sang for the operetta, *Maid of the Mill*, performed by the high school. Ruth Wilkins was their talented instructor.

The freshman class stands outside of St. Joseph Academy in 1930. The Sisters of Providence opened the school in 1875 in Yakima City. When most of the town moved four miles north, this school went, too. It graduated its first class in 1903. The school stood at N. 4th Street and E. C Street. The school operated until 1969, at which time it was consolidated with two other Catholic High Schools to become Carroll High School.

Three

A CENTER OF AGRICULTURE

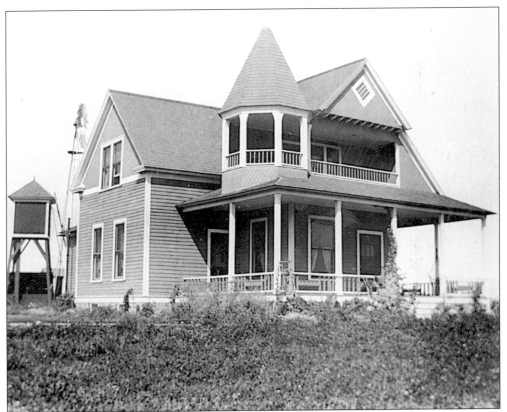

Horace M. Gilbert came to the Yakima Valley in 1897. He built this house, located at 2109 W. Yakima Avenue, in 1898. The family lived in an old barn on the property until the house was finished. He planted one half with orchards and grazed animals on the other half. The Gilberts owned the home until 1951, when Gilbert's wife died. It is now owned and operated by the Yakima Valley Museum.

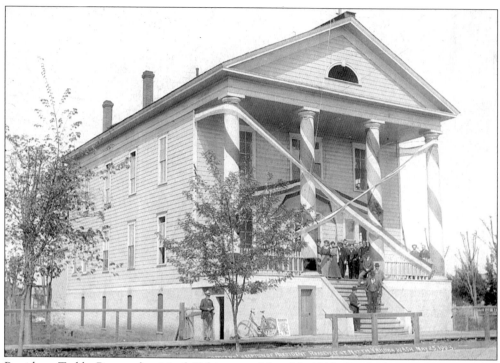

President Teddy Roosevelt visited Yakima on May 26, 1903. He had recently passed the Irrigation Act. He spoke to a large gathering about the achievements of the residents in agriculture and how much irrigation would ease their load. Roosevelt spoke from a podium erected at the corners of Naches and Yakima Avenue. Flags and bunting hung from every building. He was greeted by a group of Yakama Indians while Frank X. Nagler directed the band.

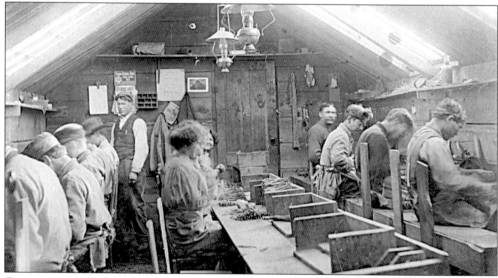

Grapes were one of the first crops to be grown in the Yakima Valley. These workers tie grape stock for planting in an early orchard about 1908. Grapes grow well in the valley due to its mild climate, long growing season, and nutrient-rich soil. Many varieties of wine grapes are now grown and support dozens of wineries from Yakima to Walla Walla.

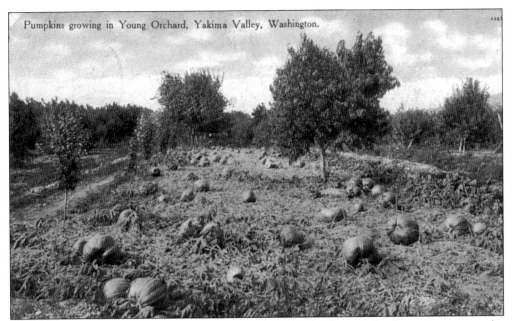

Pumpkins growing in Young Orchard, Yakima Valley, Washington.

Never ones to waste space, Yakima farmers with orchards alternated other crops among the trees. In this apple orchard, pumpkins were planted. Though they grow well here, melons and gourds have never been a large part of the Yakima economy. Today only cantaloupes represent a significant harvest.

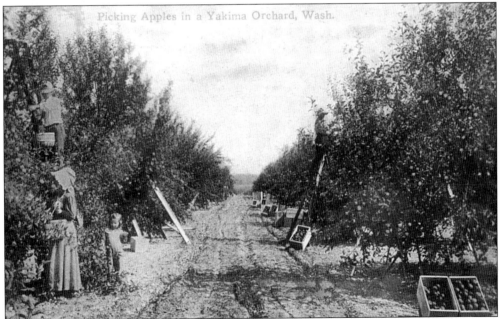

Picking Apples in a Yakima Orchard, Wash.

John Wilson Beck planted 50 apple trees and 50 peach trees in 1870 and John B. Nelson planted Winesap apples in the 1880s. These two orchards began a prosperous industry for the Yakima Valley. Some of the earliest apples grown in the Yakima valley were bellflower, blue pyramid, Rhode Island greening, rambo, winter swaugh, Peck's pleasant, and Westfield seek-no-further. All were picked by hand, sometimes a hazardous prospect.

51

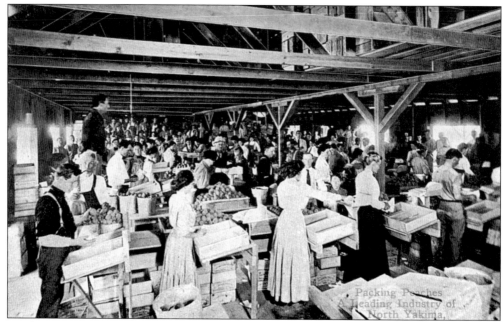

Peaches were and still are a leading industry in the Yakima Valley. Peach trees were often planted as filler trees in apple orchards. Elberta peaches were the most popular. These workers are packing peaches into crates, a very labor-intensive task. In the 1950s, Yakima County would become the eighth largest peach producing county in the U.S. Peaches are still one of the leading exports in Yakima today.

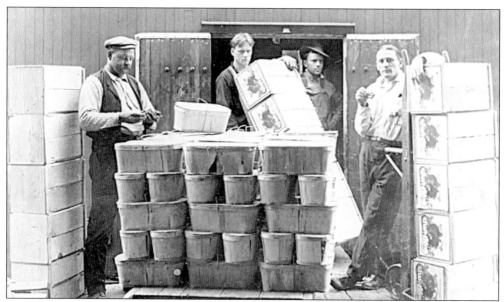

J. M. Perry built one of the first fruit warehouses in Yakima in 1900. He organized a fruit shipping company in 1905. In 1906, he built a cold storage facility. In 1910, when he added another huge warehouse and ice plant, he owned the largest fruit business in the valley. These people are working at the Perry warehouse getting a shipment ready for the railroad, whose tracks were across the street.

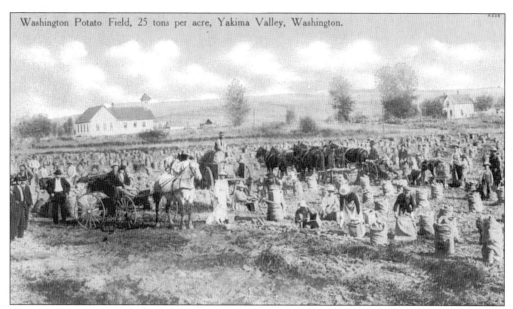

Washington Potato Field, 25 tons per acre, Yakima Valley, Washington.

If this picture is to be believed, potatoes grow quite well in the Yakima Valley. The caption claims that potato crops yielded 25 tons per acre, evidenced by the large number of full potato sacks in this field. In the early days the sacked potatoes were left in the field until they were shipped. The former owner of this picture claimed he had seen three-pound potatoes that were a foot and a half long!

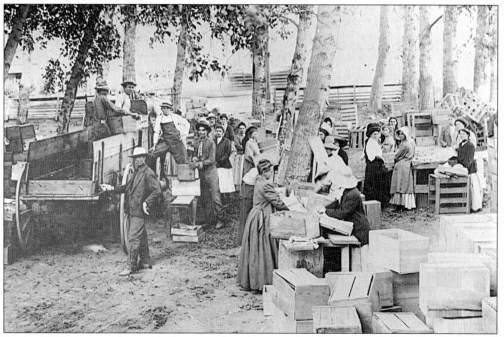

By the 1890s fruit production had increased to the point that Yakima earned its own State Board of Horticulture. These workers pack apples on site at the L.B. Kinyon ranch, one of the bigger orchards in the early 20th century. Some other early varieties of apples were red astrachan, gravenstein, wolf wax, roman beauties, spitzenburgh, New York pippin, and Winesap.

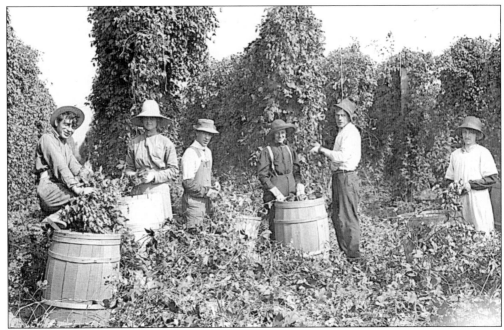

Hops, an important ingredient for making beer, have been one of the staple crops of the Yakima Valley since the 1890s. B.F. Young and John Stone brought the first hop crop to the area in 1888. Harvesting hops was very labor intensive and kept many local people employed in the industry. These pickers harvest the hops in about 1913 at the Morrier ranch, east of the Yakima River.

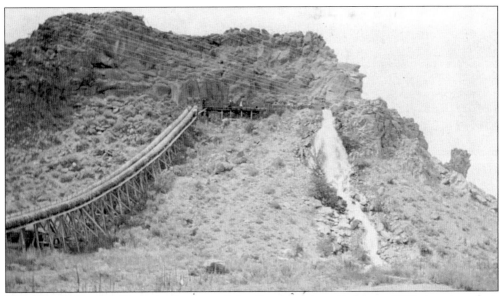

Thomas and Benton Goodwin dug one of the first irrigation ditches in 1886, to water their wheat crop. They had just five acres under cultivation. The Nelson Ditch was built in 1867, which diverted water from the Naches River. Many other ditches and canals have been built to bring the waters of the Yakima and Naches Rivers to the land. This irrigation ditch outside North Yakima dates from 1913.

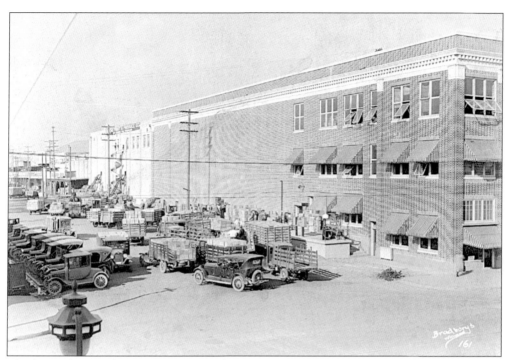

Charles Holtzinger bought and sold apples in Iowa, Minnesota, Texas, and Utah before he bought a warehouse in Yakima in 1915. The warehouse on 6th Street could store 100,000 boxes of apples. In 1922, fire forced construction of a new building on the same spot, which is pictured here. The warehouse burned again in 1926, but was rebuilt again. The company is still owned and operated by the Holtzinger family.

This apple crate label was designed by the Holtzinger Fruit Company to paste on boxes of apples. As part of his marketing strategy, Holtzinger wanted to dress up the plain brown boxes. His first brand was called Royal Purple, which he registered with the patent office. Royal Red apples were marketed in the 1940s.

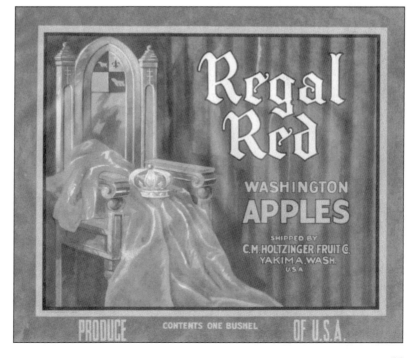

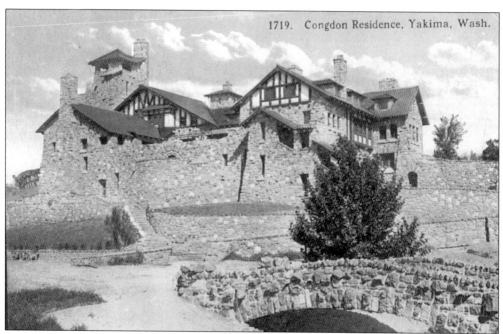

Congdon's Castle on 55th Avenue and Nob Hill Boulevard was completed in 1915. The 80-room mansion was built from native Yakima stone, dug from a quarry a few miles from town. Chester Congdon and his brother Albert built the Yakima Valley Canal in 1889. His orchard of over 35,000 trees was one of the largest orchards owned by an individual. In 1913, he added a huge fruit storage and packing plant.

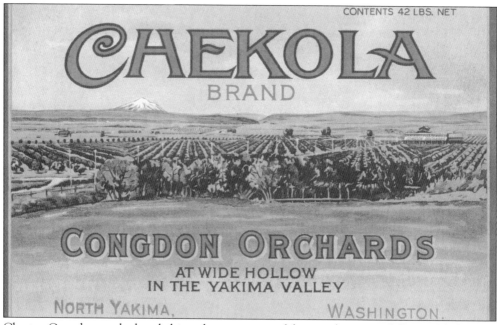

Chester Congdon packed and shipped many types of fruit under many different labels. This particular label is one of his early labels, printed about 1912. Also about this time, a standard size wooden crate was established for packing apples.

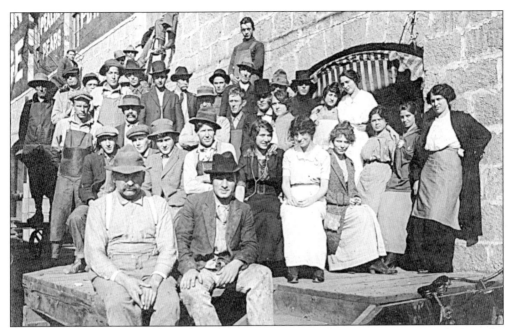

As time went on, more fruit packing was accomplished at warehouses, rather than at the orchard. The work took on the form of an assembly line production. This group takes a break from packing at a downtown Yakima warehouse, about 1920.

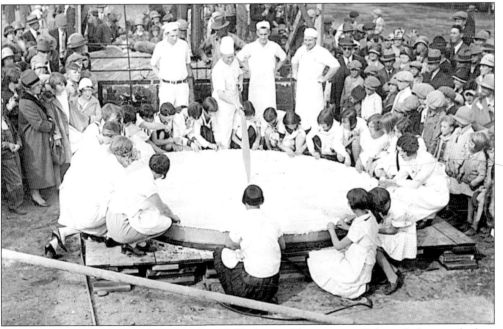

It was National Apple Week in October 1927. As a publicity stunt, Yakima bakers cooked up a one-ton apple pie. Chief cook Herman Loevenstein led a team of three other bakers. Home economics classes and girl scouts helped roll out the dough, and a special oven was built at Central School. A tinsmith made a special pan for the pie. Evaporated Fruit Inc. of Selah donated the fruit. Camera crews filmed the cutting when 1,000 people got a slice of the pie.

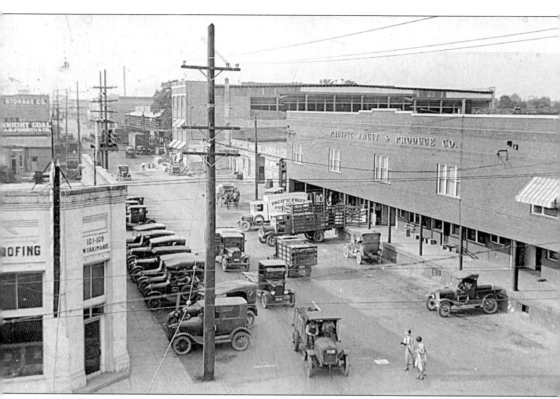

Pacific Fruit has been in business since 1902. Lloyd Garretson organized the parent company in Tacoma in 1894. Before establishing a branch in Yakima, Garretson frequently came to Yakima to purchase orchard fruit. At first Pacific Fruit occupied a warehouse owned by the Pioneer Lumber Company. Four years later, the company moved into a warehouse on N. 1st Avenue. In 1910, the company added a basement, a cold storage plant, and the building next door for warehouse space. The Yakima plant became the shipping center for a business that soon had 40 branches in three states. This picture was taken in the 1920s, after Garretson dissolved his partnership with George Youell, with Youell maintaining ownership of the downtown plant.

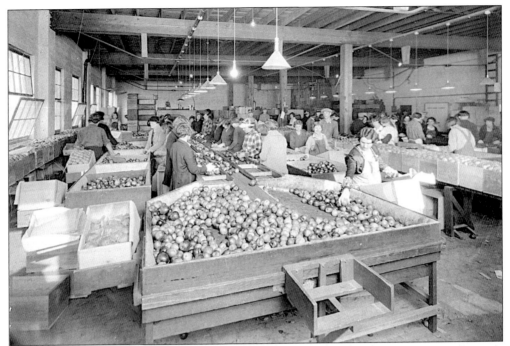

These apple packers are hard at work in 1930. By that time many improvements had been made in mechanizing the packing business. The trend was shifting and more packing was done in commercial warehouses by this time. That year was also a banner year for shipment of apples overseas—seven million boxes were shipped from Washington State.

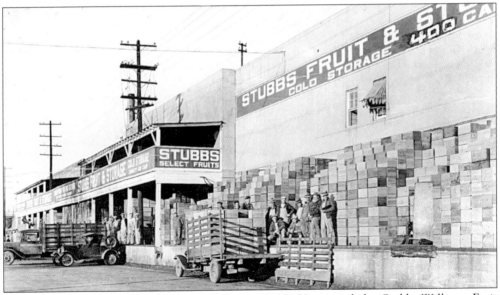

Frank F. Stubbs came to the Yakima Valley in 1917. He started the Stubbs-Williams Fruit Company in 1919. The following year, Williams sold out and the business became known as Stubbs Fruit & Storage Company. The plant was located in "Fruit Row." This picture was taken about 1932, at the height of his business. He was also an active member of the Kiwanis Club and the Chamber of Commerce.

CALPAK SUGGESTION RECORD

Suggestion No. 243

Name of Suggestor _____ Pat Reese _____ Suggestion Blank No. 28669

Branch Location _____ Yakima, Washington _____ Branch No. 125 ____ Badge No. 3495

Division Suggestion Committee at __ Portland, Oregon _____ Date received 12/19/47

To Suggestor: This will serve as acknowledgment of the suggestion submitted by you and described below.

The spirit which prompted your suggestion is very much appreciated and it has been referred to the Division Suggestion Committee. You will be advised of its action as quickly as possible.

Description of Suggestion:

> At present there is either not enough room on the peach belt for the canners to slide the peaches or, if there is enough room, there are not enough peaches to keep busy. The peaches should be continuous across the belt, so there would be ample room to slide them, more to pick the size from, and an even break for the girls opposite each other.
>
> To achieve this, the pie and slice could be sent on a belt high enough above the present one so that the girls could see across beneath.
>
> Peaches invariably come faster on one side than the other, and that side can't take it, whereas the other can't make it (money). If the belt were continuous, each side would have an even break, only one "end" girl would be needed, and less canners would be needed to hold the line.

SECRETARY - DIVISION SUGGESTION COMMITTEE

Most people don't remember that long before the Del Monte Corporation, there was Calpak. Calpak, short for California Packing Corporation, was formed in the early 20th century by a group of California fruit canners and packers. The company built the first Del Monte Food Products plant in Yakima, in approximately 1934. This suggestion form from 1947 was submitted to cannery officials to consider an improvement on the peach line.

Four
AVIATION IN YAKIMA

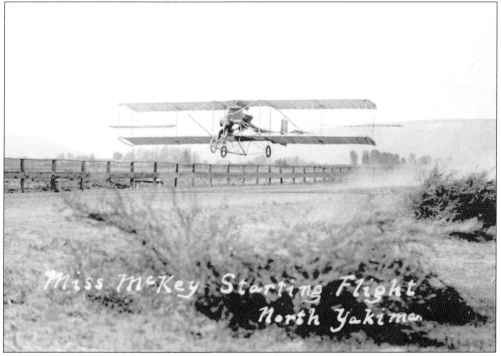

Alys McKey Bryant was the first woman to fly in Yakima. This flight took place at the Yakima Fair Grounds, on May 13, 1913, just the third flight in Yakima. She was the first woman to fly in Washington, Oregon, and Idaho. Later that year she became the first woman to fly in Canada. She also set a new record for women's altitude at 2,900 feet.

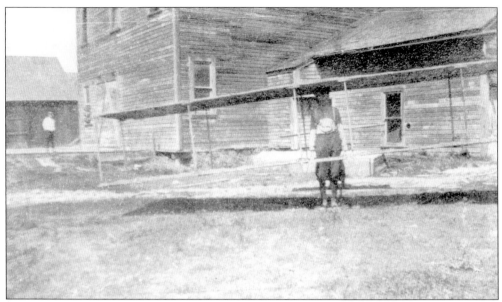

Charlie McAllister, an aviation pioneer, built his first glider in 1919. The design came from an issue of a *Popular Mechanics* magazine. Charlie was just 15 years old when he built the glider. Charlie did not own the glider for very long. A friend was flying it when a gust of wind knocked him down, injuring the friend. After complaints from the friend's father, Charlie's father chopped the glider into kindling.

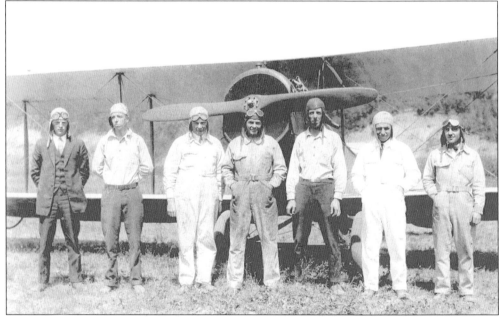

As soon as he could, Charlie and his brother Alister signed up for flight lessons. They took their training in Portland, Oregon. This is the graduating class of 1926. Charlie McAllister is second from left and brother Alister is fifth from left. Fourth from left is Tex Rankin, famous stunt pilot, barnstormer, and owner of the flight school. The McAllister Museum has the four checks that Charlie used to pay for his flying lessons.

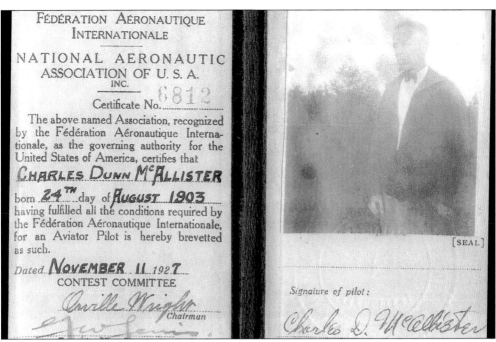

This is a picture of Charlie McAllister's original pilot's license, issued by the Federal Avionics Internationale. This organization is the precursor to the National Aeronautic Association of USA. Notice that the chairman is none other than Orville Wright. Charlie received his license in 1927.

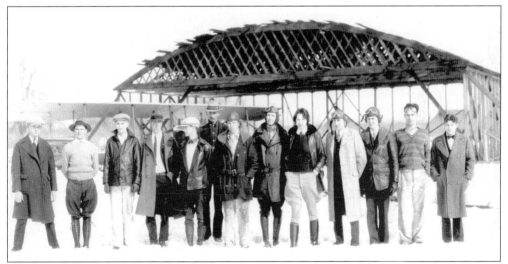

Upon his return to Yakima, Charlie McAllister started a flying school at the airport property, sponsored by Western Airlines. The first graduates of the flight school in 1928 are pictured from left to right: Ralph Koreski, Eddie Carpenter, Bob Laurent, Alister McAllister, Rolland Pease, Albert Breshears, Charles McAllister, Ormand Arnold, Helen Peters, Al Dube, Archie Hough, Bert Olding, and Zenas Schneider.

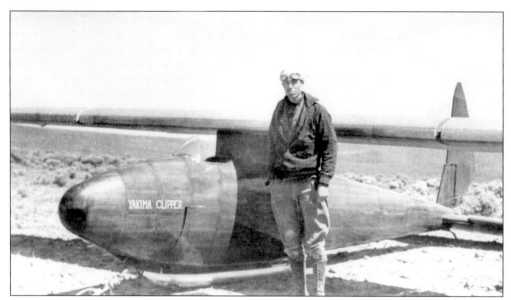

Charlie McAllister built this new glider, called the Yakima Clipper in 1932. It took him two years to build the glider, his own design, made of Sitka spruce and plywood. A year later McAllister set out to establish a gliding record. He fell short of the national record, but established a Pacific Northwest record by staying aloft for nine hours. McAllister flew the glider 40 times between 1932 and 1941.

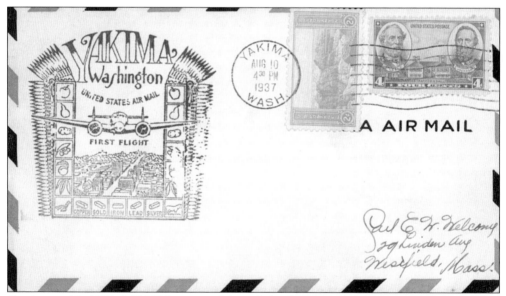

On August 10, 1937, 2,000 Yakimans celebrated the first airmail delivery. The plane touched down with nine pounds of mail and seven pieces of express mail. The plane flew away with six passengers, including Frederick Mercy Jr. and baseball legend Hunky Shaw. Over 9,000 specially stamped letters were placed on board, as shown on the envelope pictured. Several businesses mailed fliers letting the rest of the country know that Yakima products were now more available because of airmail.

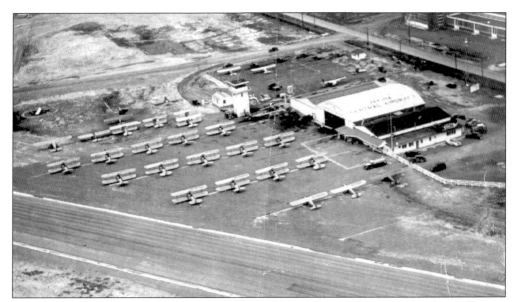

During World War II, the U.S. Department of Defense established a Naval Air Station Training Facility. This aerial view depicts Central Aircraft and the Navy N3N aircraft that the soldiers trained in. Besides flight training, the cadets also spent half of each day at the Yakima Valley Community College for classroom learning. The fairgrounds were used for temporary housing.

Pictured is Roy Phillips, one of many of the cadets that trained at the Naval Air Station in 1944. After the war, Philips worked at the Yakima weather station, from which he retired. He still lives in Yakima.

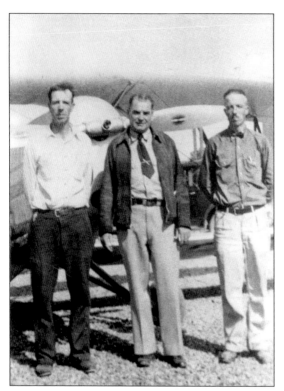

Alister McAllister (left), Tex Rankin, and Charlie McAllister remained life-long friends after the brothers trained at Rankin's school. This picture is taken approximately 1950, after Charlie was well on his way to training the 600 pilots he would ultimately teach.

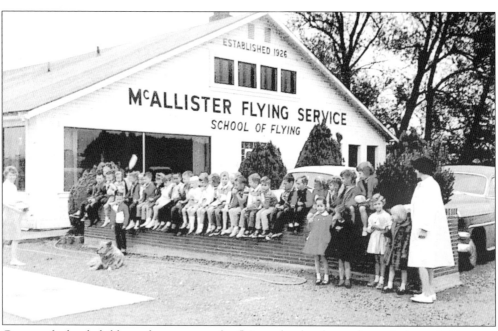

Groups of school children often came to the flying school to learn about airplanes. This group is from approximately 1950. The little girl in the white dress is the daughter of a current member of the McAllister Museum.

Five

THE 1930S AND 1940S

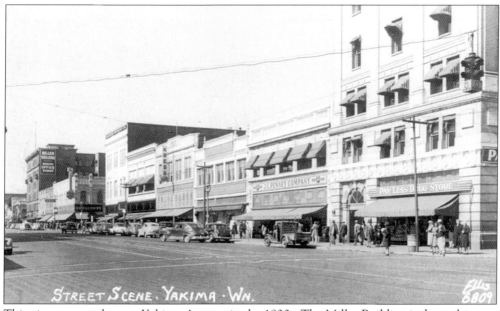

This picture was taken on Yakima Avenue in the 1930s. The Miller Building is the multi-story building in the right distance. On the corner, a sign reads Cowan Painless Dentist. In the same structure is a J.J. Newberry's store. On the near block is a Kress 5-10-25¢ Store, another J.J. Newberry's 5-10-25¢ Store, the J.C. Penney Company, and a Pay Less Drug Store. J.C. Penney is still in business, anchoring the Yakima Mall.

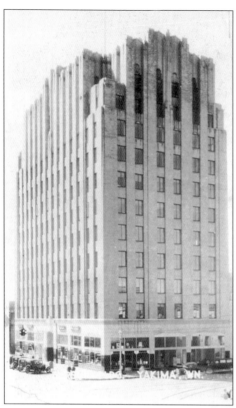

A.E. Larson opened the Larson building in 1931. It was built by architect John W. Maloney, who kept an office in the building. The building was special in that it had marble in the lobby, terrazzo corridor floors, and 13 different shades of brick. Several insurance agents, dentists, and lawyers occupied the building in the early days. The building's basement was used as an air raid shelter during World War II.

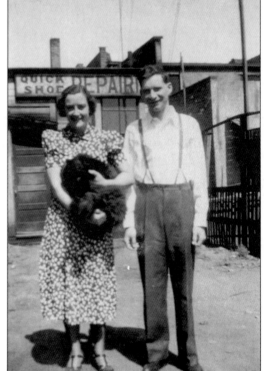

This picture of an unknown couple was taken c. 1931. The shoe repair station was likely in downtown Yakima. The hairstyles and clothing are reminiscent of the flapper era of the 1920s.

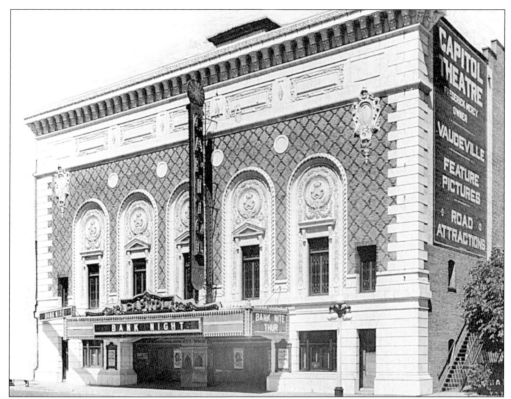

The Capitol Theatre held its grand opening on April 5, 1920, known then as the Mercy Theatre. The theater was built with a mix of Roman and Renaissance designs. Eighteen hundred people attended *Maytime*, a popular musical stage play in those days. The designer was B. Marcus Priteca from Seattle. The theater played road shows, vaudeville, and motion pictures. This picture was taken in the 1930s after several years of successful shows.

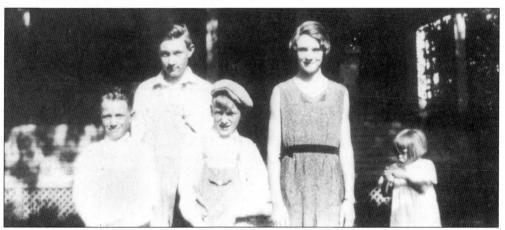

Pictured from left to right are Magnus, James, Jack, Rose, and Mary Regina Rooney, at their house on S. 12th Avenue, c. 1932. The family represented many Yakima businesses. Magnus worked for the Safeway grocery store chain. James worked for the U.S. Department of Agriculture. Jack was a Weyerhaeuser employee. Rose was one of thousands who have worked for Calpak over the years. Mary Regina left Yakima and lived in Seattle.

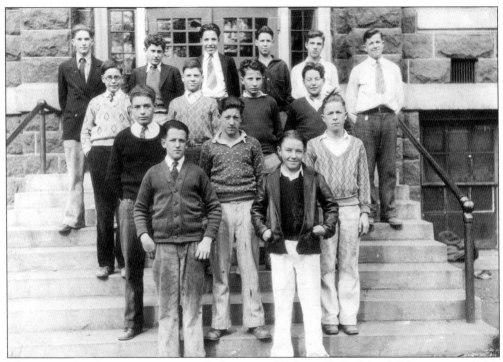

This group of sophomores poses outside the steps of Yakima High School. The year was 1933. During the Great Depression years, enrollment in the school district soared until it reached about 1,700 students. Federal and state aid, combined with low wages and low material costs made several building projects possible throughout the 1930s.

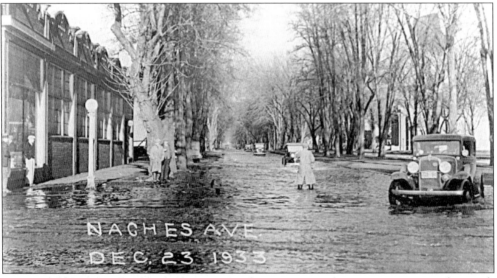

Unseasonably warm weather and incessant downpours in the mountains caused record-breaking levels on the Yakima and Naches Rivers in late 1933. Road closures from flooding and avalanches surrounded the Yakima Valley. These homes on Naches Avenue are about a mile and a half from the river and were considerably damaged from the water. The backup of water into the Cascade Lumber Mill ditch, which overflowed, caused this area of flooding.

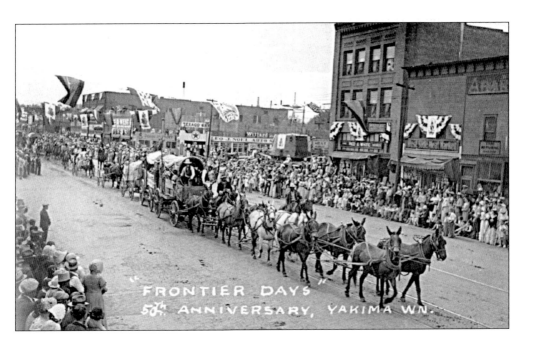

Yakima celebrated 50 years as an incorporated city on May 17, 18, and 19, 1935. To get into the spirit of the event, all automobiles were banned. In the Sunday parade alone, there were 4,200 horses in the caravan. Citizens dressed up in various costumes, representing cowboys, soldiers, and early Yakima farmers. Others dressed in typical gay '90s fashion. Countless Indians joined the parade in full regalia. Others joined the parade in covered wagons, to simulate the Longmire wagon train, which crossed the Yakima Valley in 1853. Other events included foot races, vaudeville acts, a pioneer dance, and a rodeo. A cake seven feet by five feet was baked to celebrate Yakima's birthday. Only a woman whose dress caught on fire and an unfortunate fatal accident in which a cornice from a building collapsed killing one and injuring 35 others marred the events.

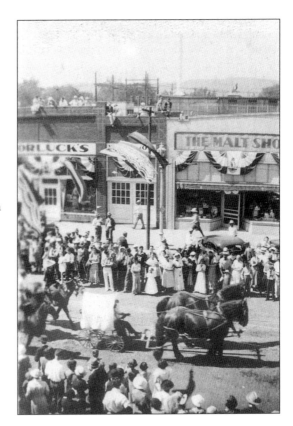

Common Schools of the State of Washington

This Certifies That _Magnus B. Rooney_, of District No. _33_, County of _Yakima_, has passed a creditable examination in the subjects of the first eight years of the Common School Course, has maintained a high standing in deportment, and is therefore granted this

Certificate of Graduation

which entitles the holder to enter any High School in the State without further examination.

THE FOLLOWING CREDITS ARE BASED ON A
SCALE OF 100 IN EACH SUBJECT:

Reading	92	Grammar 81
Spelling	95	Geography 89
Writing	92	Physiology 95
Arithmetic	97	U.S.Hist.and Civics 92
Manual Training		Agriculture 83
Home Economics		Total 812

Dated this _24th_ day of _May_, 19_35_

L. Pearle Hibarger
County Superintendent

John H. Faymler
Teacher or Principal

Earle A. Pettman
Chairman of the Board of Directors

J. G. Allen
Clerk of the Board of Directors

N. D. Showalter
Superintendent of Public Instruction

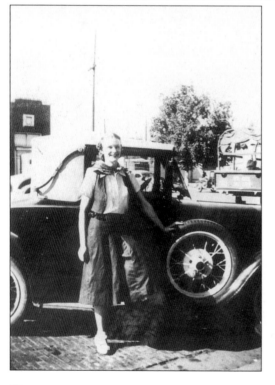

This certificate is typical of those given in the Yakima School district. The certificate, issued to Magnus Rooney, certifies that he has completed the requisite courses to go on to any high school in Yakima. Judging by his grades, it appears Rooney was a good student, though evidently it was not required for boys to attend home economics.

Rose Rooney shows off her car, a Model A Roadster. The car was approximately five years old when this picture was taken in 1936. She still lived at home on 12th Avenue. It seems cars were still enough of a novelty in those days, that people were quite proud to own them and record the moment!

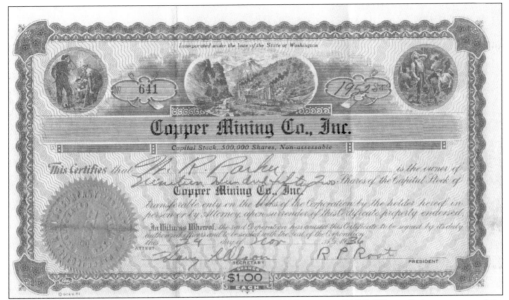

The Copper Mining Company issued this stock certificate in 1936. Though incorporated in Yakima, the mine was located south of Bumping Lake in the northwestern part of Yakima County. Ruben Root and Cyrus Fletcher formed the company about 1905. Root and his partners worked on the mine for 45 years, never seeing a profit. All the investors' money was spent on building roads to the area and acquiring the necessary machinery.

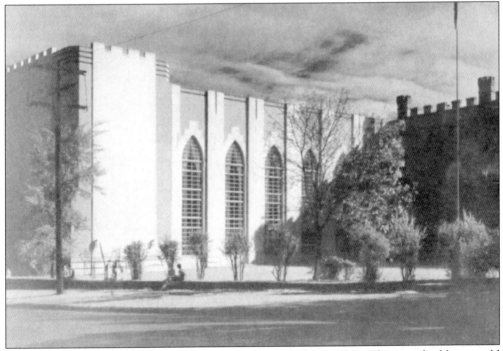

Pictured is Yakima High School's new auditorium built in 1936. The new building could accommodate 1,600 people. The old auditorium was remodeled into a library. In 1937, a third floor was added to Yakima High School. The two additions cost $207,688.

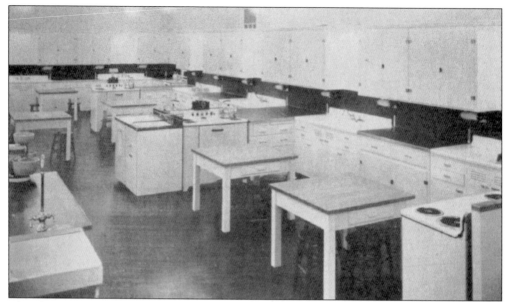

The third story built in 1937 added to the 6th Avenue building contained a new food laboratory, a study hall, a sewing room, and several classrooms. Pictured is the new foods laboratory where students attended home economics classes. The caption to this picture in the 1938 high school annual reads: "We can live without music and art and books, but civilized men cannot live without cooks."

Frances Galloway was a long-time favorite teacher of Yakima High School students. She was also a school counselor and librarian. In 1938, she retired from teaching. The high school yearbook of 1938 was dedicated to her.

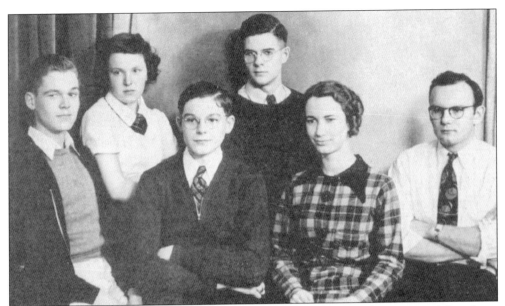

The Yakima High School Debate Team had a good record in 1938. The question debated was whether the States should adopt a unicameral (one house) system of legislation. The team defeated Mabton, Wenatchee, Everett, and Kennewick, and lost to Wapato. The members are, from left, Dick Robinson, Betty Beardsley, Bill Morthland, Kenneth Robinson, Molly Jane Lugar, and Charles Thomas. Their advisor was Mr. Campbell.

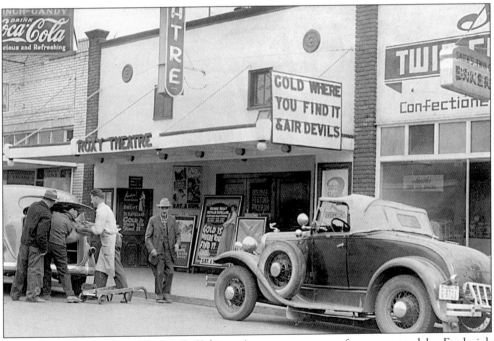

The Roxy Theater, located at 7 E. Yakima Avenue, was one of many owned by Frederick Mercy. The theater was known as Roxy and Lyric when it first opened in 1936. This picture was taken approximately 1938. The Roxy was one of the first theaters to have a double auditorium. It was torn down in 1958.

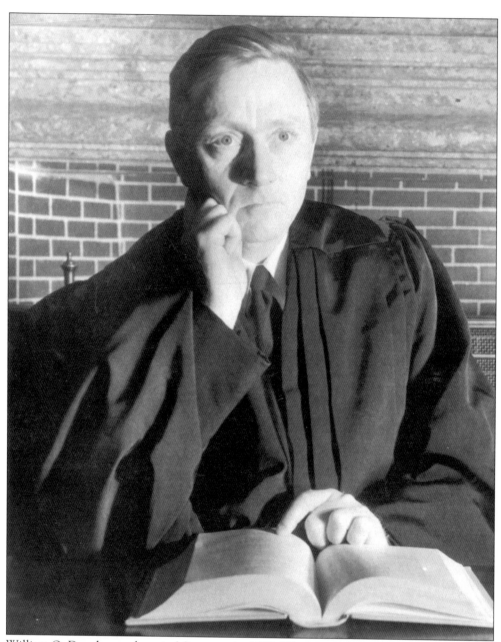

William O. Douglas was born in Minnesota in 1898. When a tot, his family moved to Yakima. As a boy he had polio, so he spent many hours hiking in the Cascade Mountains to get stronger. He improved enough to play on the North Yakima High School basketball team. He graduated from Whitman College and taught at Yakima High School. He went on to Columbia University law school and upon graduation, he taught law at Yale University. For a short time he engaged in private practice before being nominated to the U.S. Supreme Court by President Roosevelt in 1939 at the age of 41. He served until his retirement in 1975. During his career he wrote more opinions than any other judge. He also wrote more than 20 books. Growing up near the Cascades gave Douglas a strong appreciation for nature, the preservation of which he championed in legal decisions. He died in 1980.

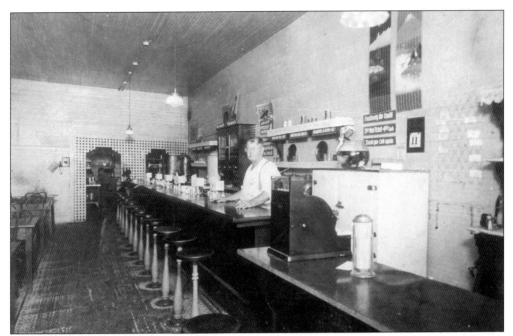

The New Panama Café was located at 504 1/2 W. Yakima Avenue. Proprietor Joseph Reese stands at the counter, ready for the day's first customers. The restaurant was open from 1928 to approximately 1942.

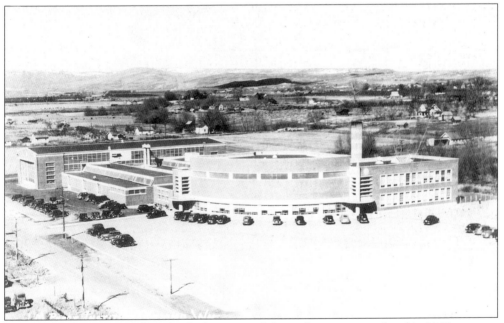

The J.M. Perry Institute of Trades, Industries, and Agriculture was completed in 1940 at a cost of $650,000. The school was built as a legacy from Perry, who believed in helping the younger generations to better themselves. Its first classes opened on January 2, 1941. During World War II, the school trained pilots. Since then, it has always kept pace with technology, continually adding new courses and degree programs that are in demand by today's businesses.

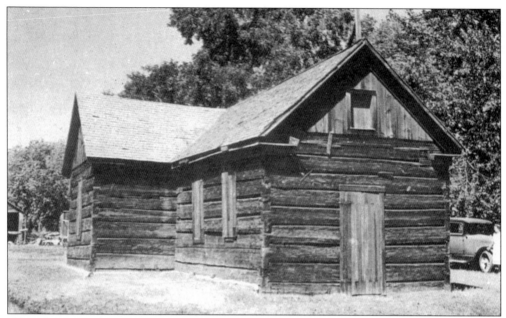

After the original mission was burned down, the priests left and never returned. But several years later Father L.N. St. Onge and Father J.P. Boulet reestablished the mission as St. Joseph's. This log chapel is how the mission appeared in 1940. The mission stood throughout the 1970s.

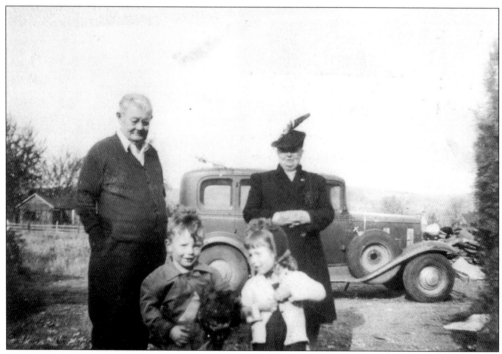

Joseph and Sabina Reese enjoy spending time with their grandchildren, Johnny Reese and Margaret Reese, who were cousins. Johnny is carrying a live chicken and does not seem to be afraid of it. Sabina is wearing one of her characteristic feathered hats; she had a special fondness for hats of all shapes and sizes. In the background is their Towne Sedan of early 1930s vintage.

Mary and Cecil Parker relax outside of their new home on 4th Avenue. This picture was taken approximately 1940, shortly after their marriage. This new Plymouth replaced the old car formerly owned by Parker.

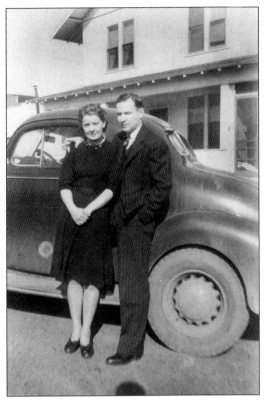

Here is Mary Parker with the couple's old car. It is a Model A Ford Coupe from 1930 or 1931.

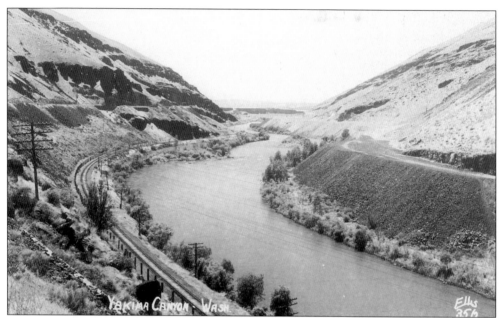

Max Mook, a highway engineer, figured a road through the Yakima River Canyon to Ellensburg would save time for travelers and be cheaper to maintain than the current route. The estimated completion date of September 1, 1924, was missed as blasting through the rocky cliffs was more difficult than expected. Enough of the work was done by September 22 that the inaugural drive to the Ellensburg rodeo could still be undertaken. The road was finally finished two years later.

No. (29) TO BE EXCHANGED FOR 1250--SHARES

AMIKAY MINES COMPANY
YAKIMA, WASHINGTON
INTERIM RECEIPT
NOT NEGOTIABLE · NOT ASSIGNABLE · NOT A STOCK CERTIFICATE

This Certifies That J.B.Reese Sr.

Is Entitled to Receive

--- One Thousand, Two Hundred, Fifty ------------------------ Shares
of the common stock of the AMIKAY MINES COMPANY, Yakima, Washington, and that a certificate for said shares will be delivered to the payee hereof in accordance with the terms printed on the back hereof.

PRESIDENT SECRETARY

This stock receipt for the Amikay Mines Company was issued sometime in the 1940s. It is not an actual stock certificate but a promissory note for the company to award the "paid for" amount of shares when they became available. It is not certain where this mine is located but may have been in the Bumping Lake area, where other miners were prospecting. Note the name of the company is Yakima spelled backwards.

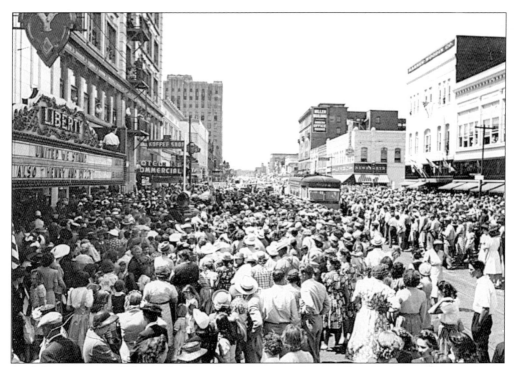

As did many cities, Yakima challenged its citizens to support the war by purchasing savings bonds, a good investment then and today. This crowd on Yakima Avenue turned out for a 1942 war bond drive. Apparently, the city set war bond sales records. The Liberty Theater is in the left foreground. The "twin towers" of the Larson Building (left) and the Miller building (right) stand in the background.

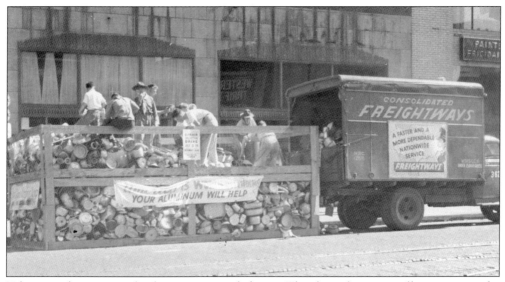

Yakimans also got involved in scrap metal drives. This large bin is a collection point for aluminum. In July of 1943, the local Optimist Club organized an aluminum drive to support the war effort. It is not known exactly where this picture was taken, but a sign reflected in the building's window says Western Thrift Store.

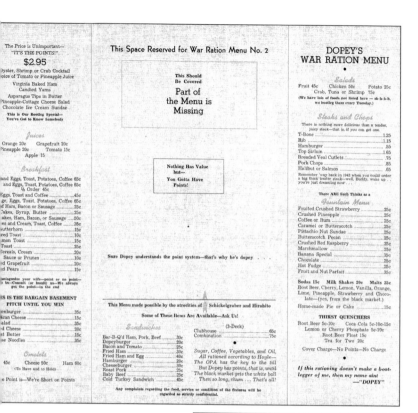

The Price is Unimportant—
"IT'S THE POINTS!"

$2.95

Oyster, Shrimp or Crab Cocktail
Choice of Tomato or Pineapple Juice
Virginia Baked Ham
Candied Yams
Asparagus Tips in Butter
Pineapple-Cottage Cheese Salad
Chocolate Ice Cream Sundae

This is Our Bootleg Special—
You've Got to Know Somebody

Juices

Orange 20c Grapefruit 20c
Pineapple 20c Tomato 15c
Apple 15

Breakfast

and Eggs, Toast, Potatoes, Coffee 65c
and Eggs, Toast, Potatoes, Coffee 65c
Eggs, Toast and Coffee ...45c
ge, Eggs, Toast, Potatoes, Coffee 65c
f Ham, Bacon or Sausage ...25c
akes, Syrup, Butter ...25c
akes, Ham, Bacon, or Sausage ...50c
es and Cream, Toast, Coffee ...25c
utterhorn ...15c
red Toast ...10c
mon Toast ...15c
Toast ...20c
Cereals, Cream ...20c
Sauce or Prunes ...10c
d Grapefruit ...20c
d Pears ...15c

antagonize your wife—point or no point—
In—Consult (or Insult) us—We always
get the point—in the end

IS IS THE BARGAIN BASEMENT
PITCH UNTIL YOU WIN

enburger ...35c
can Cheese ...15c
alad ...30c
d Cheese ...30c
st Butter ...15c
se Noodles ...35c

Omelets

45c Cheese 50c Ham 60c
(To Have and to Hold)

e Point is—We're Short on Points

This Space Reserved for War Ration Menu No. 2

This Should Be Covered
Part of the Menu is Missing

Nothing Has Value but—
You Gotta Have Points!

Sure Dopey understands the point system—that's why he's dopey . . .

This Menu made possible by the atrocities of Schickelgruber and Hirohito

Some of These Items Are Available—Ask Us!

Sandwiches

Bar-B-Q'd Ham, Pork, Beef ...30c
Dopeyburger ...20c
Bacon and Tomato ...25c
Fried Ham ...30c
Fried Ham and Egg ...40c
Hamburger ...20c
Cheeseburger ...30c
Roast Pork ...25c
Baby Beef ...25c
Cold Turkey Sandwich ...45c

(3-Deck)
Clubhouse ...65c
Combination ...75c

Sugar, Coffee, Vegetables, and Oil,
All rationed according to Hoyle—
The OPA has the key to the till
But Dopey has points, that is; until
The black market gets the white ball
Then so long, chum . . . That's all!

Any complaints regarding the food, service or condition of the fixtures will be regarded as strictly confidential.

DOPEY'S WAR RATION MENU

Salads

Fruit 45c Chicken 50c Potato 25c
Crab, Tuna or Shrimp 75c
(We have lots of foods not listed here — sh-h-h-h, we bootleg them every Tuesday.)

Steaks and Chops

There is nothing more delicious than a tender, juicy steak—that is, if you can get one.

T-Bone ...1.25
Rib ...1.15
Hamburger ...55
Top Sirloin ...1.65
Breaded Veal Cutlets ...75
Pork Chops ...85
Halibut or Salmon ...65

Remember 'way back in 1942 when you could order a big thick tender steak—well, Buddy, wake up ... you're just dreaming now ...

There ARE Such Thinks as a
Fountain Menu

Fruited Crushed Strawberry ...25c
Crushed Pineapple ...25c
Coffee or Rum ...25c
Caramel or Butterscotch ...25c
Pistachio Nut Sundae ...25c
Butterscotch Pecan ...25c
Crushed Red Raspberry ...25c
Marshmallow ...25c
Banana Special ...35c
Chocolate ...25c
Hot Fudge ...25c
Fruit and Nut Parfait ...35c

Sodas 15c Milk Shakes 20c Malts 25c
Root Beer, Cherry, Lemon, Vanilla, Orange, Lime, Pineapple, Strawberry and Chocolate—(yes, from the black market.)
Home-made Pie or Cake ...15c

THIRST QUENCHERS
Root Beer 5c-10c Coca Cola 5c-10c-15c
Lemon or Cherry Phosphate 5c-10c
Root Beer Float 15c
Tea for Two 20c

Cover Charge—No Points—No Charge

If this rationing doesn't make a bootlegger of me, then my name aint
—"DOPEY"

Dopey's Restaurant was open for just a few short years during World War II. Like many restaurants, Dopey's, located at 320 East Yakima Avenue, operated when some foods were severely rationed and others were not available at all. This special war ration menu was printed during those years. But the owners definitely had a sense of humor, despite those hard times. One note says, "We have lots of foods not listed here—sh-h-h-h, we bootleg them every Tuesday!" Another saying was, "This menu made possible by the atrocities of Schickelgruber and Hiroshito."

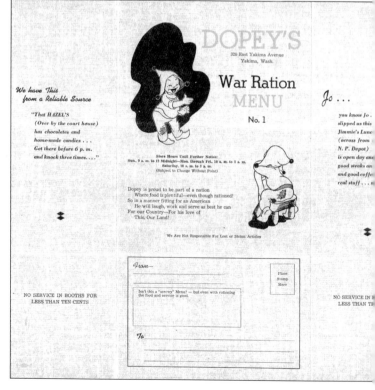

We have This from a Reliable Source

"That HAZEL'S (Over by the court house) has chocolates and home-made candies ... Get there before 6 p.m. and knock three times...."

NO SERVICE IN BOOTHS FOR LESS THAN TEN CENTS

DOPEY'S
320 East Yakima Avenue
Yakima, Wash.

War Ration MENU
No. 1

Store Hours Until Further Notice:
Sun. 9 a.m. to 12 Midnight—Mon. through Fri. 10 a.m. to 1 a.m.
Saturday, 10 a.m. to 2 a.m.
(Subject to Change Without Point)

Dopey is proud to be part of a nation
Where food is plentiful—even though rationed!
So in a manner fitting for an American
He will laugh, work and serve as best he can
For our Country—Thus his love of
This, Our Land!

We Are Not Responsible For Lost or Stolen Articles

From—

Place Stamp Here

Isn't this a "screwy" Menu? — but even with rationing the food and service is good.

To—

Jo...
you know Jo...
slipped us this
Jimmie's Lunc...
(across from
N.P. Depot)
is open day an...
good steaks an...
and good coffe...
real stuff ... n...

NO SERVICE IN B...
LESS THAN TE...

It seems the "Big One" was never far from anyone's mind. In the 1940s, St. Elizabeth's Hospital distributed baby books to new mothers. This war bond advertisement was contained in the baby book. The ad encouraged new mothers to invest in their country and to help it stamp out the enemy.

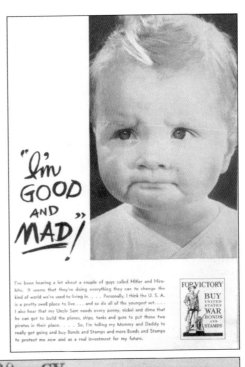

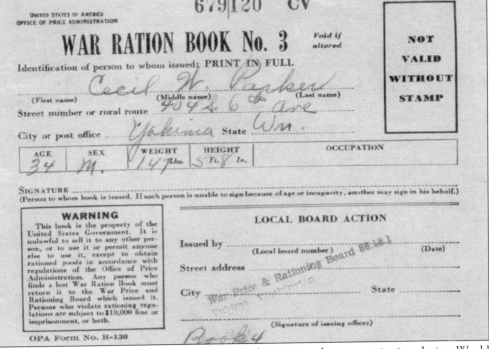

Like citizens of other cities across the nation, Yakima was subject to rationing during World War II. Ration books like the one pictured were issued for purchase of everything from sugar to gas. The bearer was warned not to throw away the ration book when empty since presenting it may be required to obtain more stamps. The bearer was also told that anyone finding a ration book lost by someone else was required to return it to the issuing rationing board.

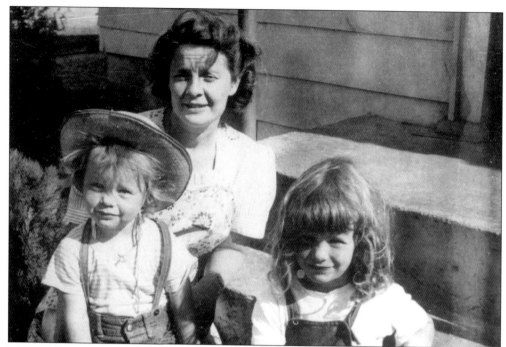

Mary Parker enjoys the company of her nieces Kathleen and JoAnne Reese. This picture was taken approximately 1948, when Kathleen was two years old and JoAnne was four years old. The Parkers lived on W. Viola Avenue.

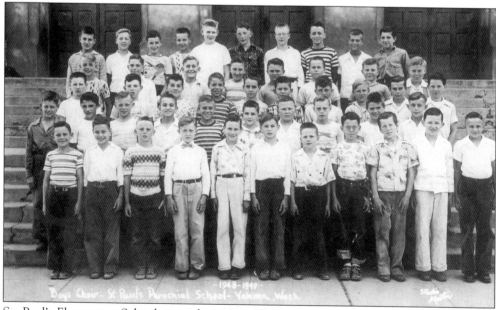

St. Paul's Elementary School opened in 1914. The school was first held in the Dominican Convent until a school building opened the following year. Academics were long established by the time the St. Paul's Cathedral was built on the same lot. This boy's choir sang at the church during the 1948–49 school year. The boys are mainly fourth graders. The old school was torn down when a new one opened for the 1950 school year.

Six
THE YAKIMA
TRAINING CENTER

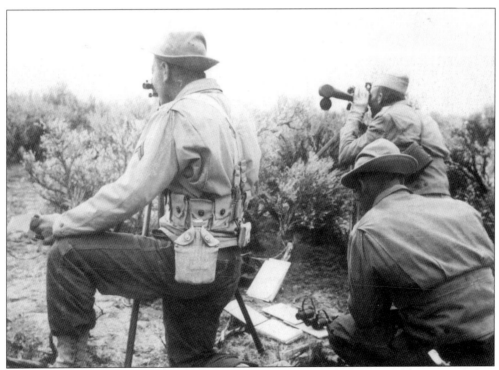

Just before the U.S. entered World War II, the army decided it needed a base to conduct artillery training in the Pacific Northwest. This area in Washington was selected as a central location. When it first opened, the base was known as the Yakima Anti-Aircraft Artillery Range. The military used the area for range firing and small unit tests. This picture, taken in 1941, shows an impact area, where spotters give coordinates for target shooting.

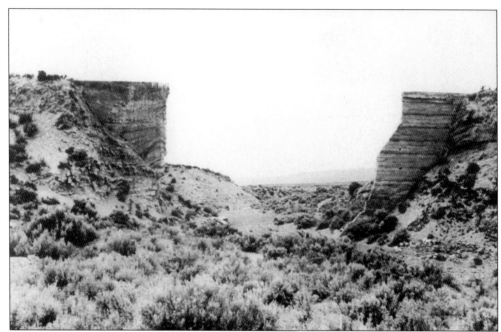

When the borders were drawn around the firing range, the remains of the former "town" of Spitzenburg were within the fence. The name came from a popular apple variety. In the early 20th century, the area had been touted as a perfect location for growing crops and making a good living on a small plot of land. Pictured are the remains of the second dam.

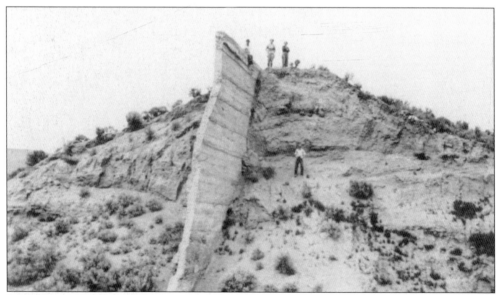

Spitzenburg Dam would anchor an irrigation system that could water approximately 4,500 acres. The people in this picture give an idea of the size of the dam. The first dam, built by Pleasant Valley Irrigation Company, was washed out by the high water of Selah Creek. Record snowfall and the spring flooding of 1910 washed out the second dam. After that the irrigation company folded, leaving behind the ruined dam and a half dozen business, including a restaurant.

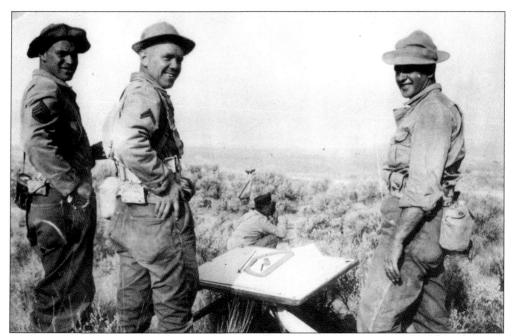

Battery A of the 147th Field Artillery Battalion take a break for the photographer. These men are known as forward observers. These men watch artillery explosions and radio in adjustments for live fire exercises. This exercise took place at what used to be known as the Taylor Ranch.

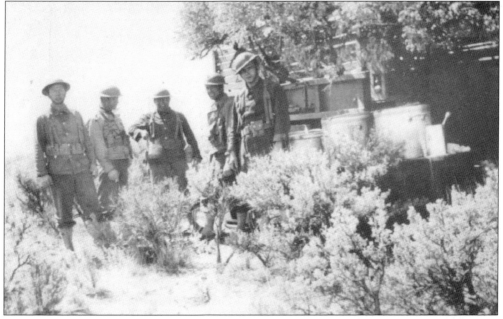

Members of Battery C of 204th Field Artillery Battalion take a break on exercises. They are standing by a field mess site. Such mobile units could provide hot food and soups that could be prepared from boiled water. Cold and packaged food would be that which the soldiers carried with them. Note that this picture, taken in 1942, shows the soldiers wearing uniforms modified from World War I era clothing.

Captain Duffy from Salt Lake City, Utah was part of a unit that trained in Yakima in 1942. He is believed to be part of a Signal Corps. Such units were used to aid in the movement of vehicles or aircraft.

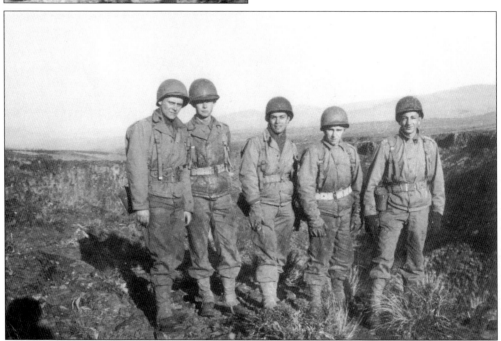

The 14th Observation Battalion from Ft. Sill, Oklahoma, visited the Yakima Firing Center in 1943. These men were attending forward observer training. Note the stark desert location in the background. Old lava beds of solid basalt rocks created many canyons in the area, making training a little trickier than it might first appear.

Not all was serious at the Yakima Firing Center. Occasionally the troops got a little rest and relaxation. In 1943, actor Micky Rooney (top, center) was on site to entertain the troops. Such visits were very much appreciated by the soldiers.

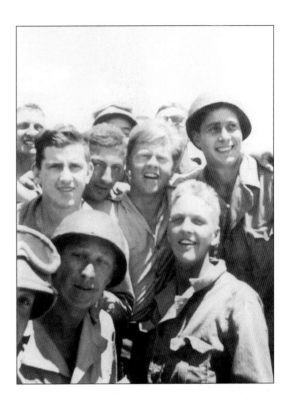

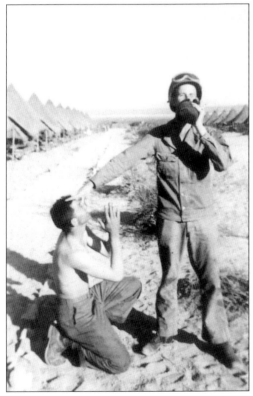

Two soldiers from the 14th Observation Battalion ham it up for the camera. One man pretends to be dying of thirst, while the other man holds him off, hogging the water to himself. The two men are surrounded by tents, at any one of which water could be obtained if really necessary. Except for field exercises, tents in the cantonment area are now all permanent wood structures.

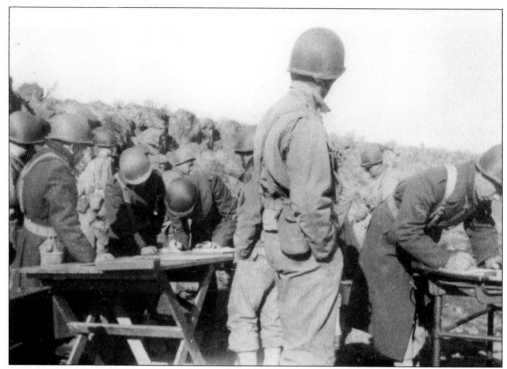

The 14th Observation Battalion practices sight and sound ranging in the field. Much like counting the seconds between seeing lightning and hearing the thunder, the soldiers counted the seconds between seeing the flash of an explosion and hearing the bang. This calculation helped adjust range of artillery fire.

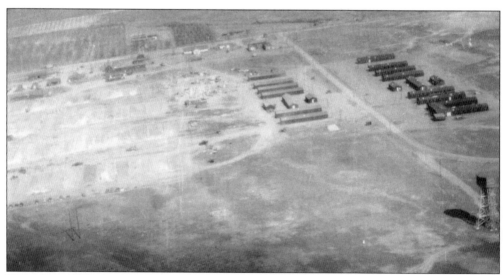

Though use of the center decreased after the war, the army decided to expand the area for future use as a training facility. The center increased from 160,000 acres to 261,198 acres. This aerial view of the Yakima Firing Center was taken in 1951. The view looks north over the main cantonment area, which shows signs of expansion. New roads have been graded and more barracks have been built.

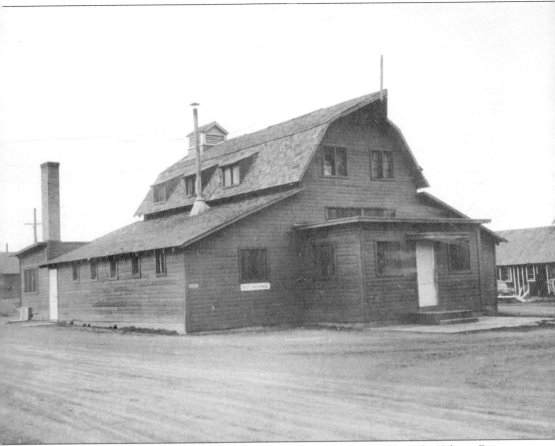

This building, originally known as Marie's Barn, was built in the 1920s. When the Yakima Firing Center was plotted, this building ended up inside the boundaries. During the Depression era, the building housed a speakeasy. During the war, Marie Green continued to operate the dance hall and bar; after the war, the bar was closed and the building became the post exchange. The upper story was removed when the building was converted to a recreation center.

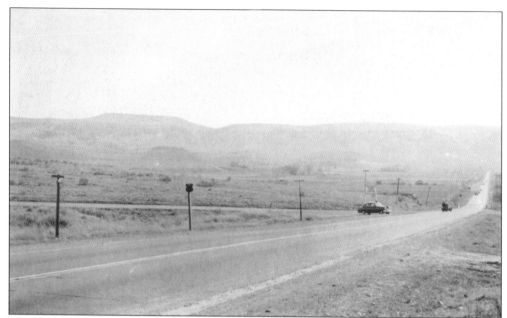

The sign marks the entrance to the Yakima Firing Center. Though the army started expanding its base here in the early 1950s, it looks as if the area is still very remote. In actuality, the city of Yakima is just on the other side of the ridge shown in the background.

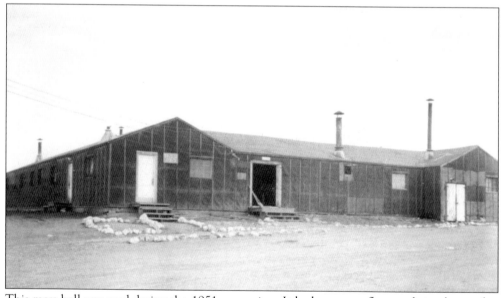

This mess hall was used during the 1951 expansion. It had concrete floor and simple wooden tables. It used a wood stove for heat. Such facilities would serve approximately 100 men at a time, twice a day.

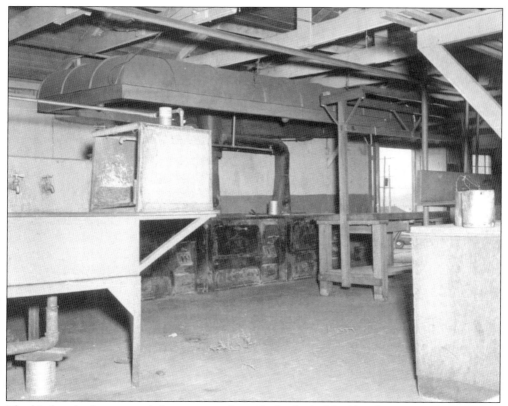

The kitchen looks very stark for an active base. It also looks like cleanliness wasn't on the top on the list for operation. Dust and tumbleweeds have blown into the kitchen area, a common hazard in this desert environment.

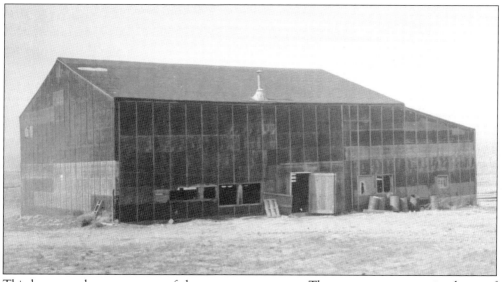

This huge warehouse was part of the quartermaster area. The quartermaster was in charge of supplies, and ordered everything from uniforms to canteens to bed linens. With the growth of the center, more supplies were needed.

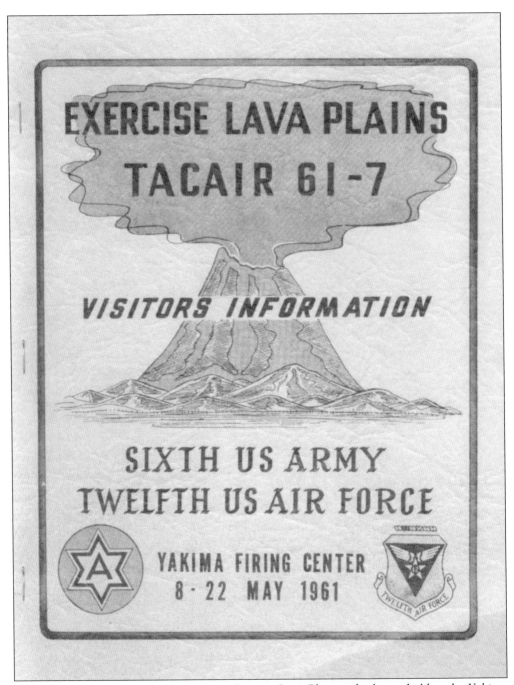

This information booklet commemorates Exercise Lava Plains, which was held at the Yakima Firing Center May 8 through 22, 1961. The exercise was open to the public, though citizens driving private vehicles on site were required to show proof of adequate insurance. The exercise was a combined air/ground training conducted by both Army and Air Force personnel. This booklet was handed out to visiting combat units and gave information on billeting, dress code, security clearances, and other details. A map of the firing center and Washington State tourists brochures were also included.

Seven
MODERN YAKIMA

This aerial view of Yakima was taken approximately 1940. The high school is pictured in the left background. St. Elizabeth's Hospital appears in the center background. The tall structure in right-center background is the Presbyterian Church. In the foreground are Hays-Paskill Co. Cold Storage, E.E. Sampson Company Fruits and Produce, and Yakima Grocery Co. Most of the buildings pictured still stand today.

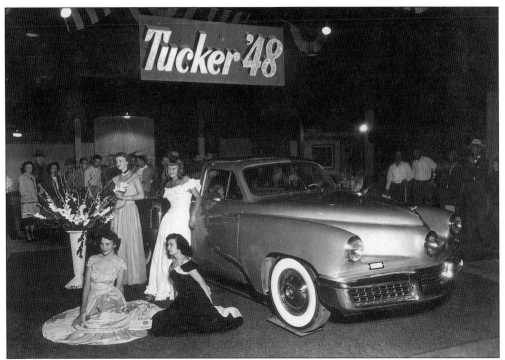

This picture was taken by Ozzie Martin, who owned Ozzie Martin Photography during the 1940s. The Tucker Fastback was being exhibited at the 1948 Central Washington State Fair in Yakima. The brainchild of Preston Thomas Tucker, the car was unique in that its engine was in the back. As it turned out, only 51 "Tucker Torpedos" were built. The car never went into production as the company was forced to close after charges of fraud.

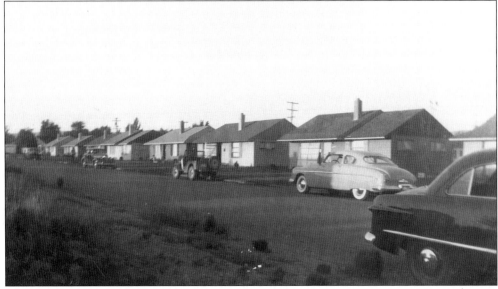

As the city grew, expansion moved further and further west. Pictured is a block on 36th Avenue, just off Nob Hill Boulevard. This street is typical of those built in that era, about 1950. Note that there is very little landscaping and no trees. This area is well shaded by trees today.

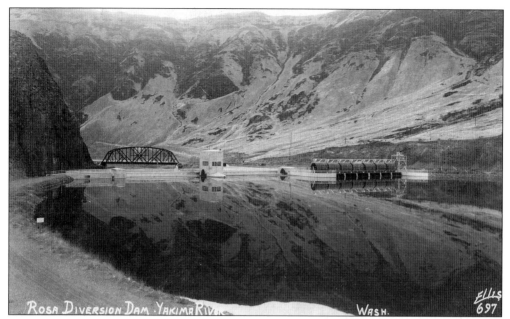

The Roza Diversion Dam is part of the Yakima Project begun by the Bureau of Reclamation. Plans for the project were approved in 1935. However, due to World War II and the diversion of manpower and material to the war effort, the entire irrigation project was not completed until 1951. Shown here is the Roza Dam on the Yakima River, north of the city. The dam is 486 feet wide at the top and 67 feet high.

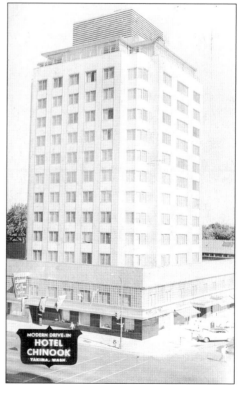

The Chinook Hotel was the pride of Yakima when it opened on May 17, 1951. The need for such a facility was realized in 1925, but the Depression and World War II put the idea on hold. A concrete shell stood for many years until 1946, when Frederick Mercy took over. When completed, the building had 14 stories with 185 rooms, kept constantly occupied by numerous conventions. The building still stands, but now houses the U.S. Attorney, bankruptcy court, and other businesses.

This picture of Johnny Reese was taken in 1952, when he was 13 years old. He was born in Yakima and enjoyed sports, especially archery. Isn't he cute?

This is the Marquette High School at N. 4th Street and E. B Street. When it first opened it was known as Marquette College, even though it was an elementary school. In 1918 it became a high school only. The first class graduated in 1922. In 1928 there were so many students that the auditorium was cut in half, and classrooms were added to the new space. High school classes were held in the new rooms.

Fraternal Order of Eagles

No. 1015

THIS **CERTIFIES** DATE _____ 19____
that Brother _____ Has **PATRON**

TO **YAKIMA** AERIE No. 289

OF **Yakima** STATE OF **Washington**

THE SUM OF_____ **DOLLARS**
SIXTY CENTS OF ANNUAL DUES FOR SUBSCRIPTION TO EAGLE MAGAZINE

DUES_____ $_____ TO LAST DAY OF_____ 19____

INIT. FEE_$_____

$_____

MEMBERS No._____

DEC 31 1952
STAMP DATE HERE

NOT VALID UNLESS COUNTERSIGNED BY MEMBER

Various social organizations have been part of Yakima's history almost since the beginning. This membership receipt is from the Fraternal Order of the Eagles, Aerie No. 289. The Eagles have had a meeting hall in Yakima since about 1920. Today the Eagles maintain a lodge at the corner of E. Chestnut and S. 4th Street. The lodge operates a bowling alley and café.

School attendance continued to grow, necessitating the addition of another school. When St. Joseph's grade school opened in 1947, all the elementary school age children left Marquette to attend the new school. Now Marquette could function as strictly a high school. A stadium was also added to the Marquette grounds. The auditorium was returned to its original size. These boys are a group of sophomores, in 1954.

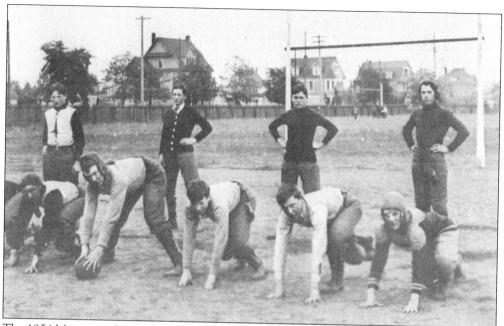

The 1954 Marquette Squires had a fantastic football season. After losing the opening game, the team went on to win 7 of 8 games. The team outscoured its opponents 175 to 92 points. The final game of the season against the Tacoma Bellarmine Lions ended in a victory and the league championship!

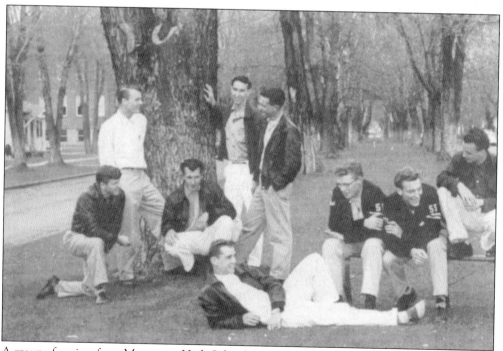

A group of seniors from Marquette High School congregates on the green at Naches Street. The street is just one block from the high school, making its park-like setting a natural place for relaxation and watching the cars go by.

The drama club had fun in 1955 putting on *The Mikado*, a famous operetta by Gilbert and Sullivan. Father David Freitag and Father Jerome Smith directed the show. The Marquette boys played both male and female parts. Isolina Batali was the only female present, as the accompanist. The costumes were especially nice too.

Not many high schools sport a ski team. But the Marquette High School supported a ski team in 1955. The team was especially proud of its giant slalom racers. Yakima is just an hour and a half from superb skiing at the White Pass Ski Resort. Other good skiing is available within a two hour drive.

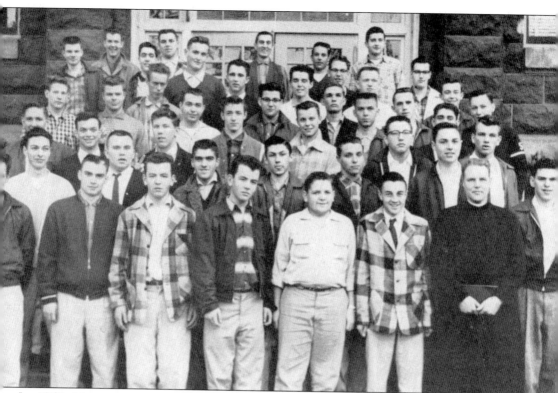

In 1957, Marquette reinstated a bowling team. The boys had a sense of humor about themselves. The high school yearbook states, "Although the team was undefeated, no trophies were awarded due to a technicality (no games—no trophies)." Of the pictured team members, the yearbook caption states, "Present but hidden from view is James Smith. The students in the third row are standing on him." No other students are identified.

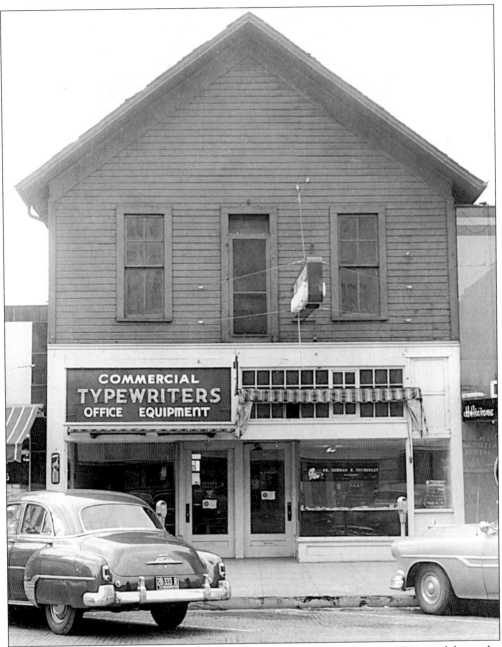

This building was originally the Centennial Hall built in Yakima City in 1876, to celebrate the 100th birthday of the U.S. Like most of the rest of the town, the building was moved to North Yakima and located at 20 S. 2nd Street. This picture taken in 1957 shows the building being used as an office supply store. When first built, the hall was just 30 by 50 feet. Political rallies, Sunday school, and band concerts were held there. On December 9, 1878, Indian agent James H. Wilbur negotiated with Chief Moses at the hall. Chief Moses agreed to help Wilbur find the murderers of the Perkins couple. Unfortunately, the building later became part of the red light district. It was remodeled several times before it was finally torn down.

The Chinook Hotel has been the location for many northwest events. In 1960, the Annual Bench and Bar Banquet, sponsored by the Washington State Bar Association, was held on September 9. These two menus were designed to commemorate the event. Attendees had a choice of Chinook salmon or prime rib. Governor Albert D. Rosellini spoke as did Calvin W. Rawlings, a guest speaker from Salt Lake City. Nine members of the Washington State Supreme Court were the honored guests.

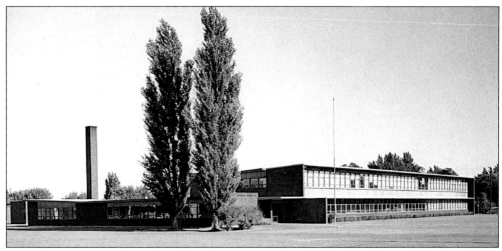

When the Yakima Valley Community College was established in 1928, it was only the third two-year college in the state. It was first held at Columbia School. A new campus opened in 1949, at 16th Avenue and Nob Hill Boulevard. The school had 11 buildings on 20 acres. Many of Yakima's leading citizens donated money to the college, including A.E. Larson, Alexander Miller, and Ralph Sundquist, a prominent orchardist. This picture was taken about 1960.

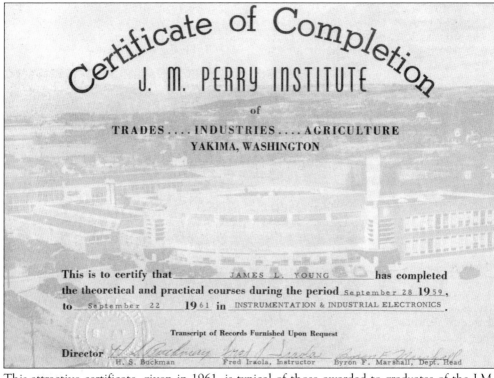

This attractive certificate, given in 1961, is typical of those awarded to graduates of the J.M. Perry institute. This particular certificate was awarded for completion of the Instrumentation and Industrial Electronics course of study, an extremely popular program that had a waiting list for enrollment. The program even got the attention of the President of the Instrumentation Society of America, who visited Yakima.

In 1961, the 10-1 record of the boys' basketball team at Central Catholic High School was enough to take them to the district tournament. They won three of four games in the playoffs to advance to the state tournament. There they lost to Lynden and Chelan, but it was a great showing for a team just in its third year. Their coach was Mr. Kenneth Bongers.

This group of girls attended Central Catholic High School, which opened in 1958. The girls pictured, from left to right, are Hazel Satler, unidentified, Ramona Palm, Catherine Newman, Mary Roach, Judy Stewart, and Marilyn Sherry. The girls would graduate in 1962. These colorful skirts were a very popular fashion at the time.

Sadly the boys' basketball team of Central Catholic High School did not fair as well in 1962. Practice games against area schools netted just a 3-5 record. Regular district games resulted in a 3-9 record. Coaching the boys was Father Frederick Brenner.

YAKIMA CENTRAL CATHOLIC
HIGH SCHOOL

Second Annual Commencement Exercises

May 30, 1962 2:00 P.M.

Holy Family Center

His Excellency
The Most Reverend Joseph P. Dougherty, D.D., LL.D.
Bishop of Yakima
Presiding

This small pamphlet commemorated the 1962 graduation ceremonies at Central Catholic High School. State Attorney General John J. O'Connell addressed the students. The valedictorian was Robert John Pas and the Salutatorian was Diana Sue Hatzenbeler. The students also attended a Baccalaureate Mass at St. Paul's Cathedral to celebrate their graduation. A celebratory breakfast was held at the Holiday Motor Hotel.

This unusually painted Volkswagen van was operated by Larson's Spray Bug, located on Washington Avenue, by the airport. The company specialized in weed control, insect control, and fertilizer. The company prided itself on the most modern methods. Oddly, this business does not appear in old Yakima phone books. Its address appears as Economy Pest Control, from 1953–1957. In the 1960s, the business was a helicopter-based crop dusting service.

In 1974, the Yakima River Canyon looks much the same as it did when the first irrigation ditches drained it to Yakima orchards and the first roads were graded. This photo looks south, toward Yakima. The railroad is on the opposite side of the canyon from the road. The train is from the Amtrak line, one of many that traveled the canyon.

The Yakima Interurban Trolley was celebrating restoration of the old trolleys in 1974. The event attracted railroad buffs from around the country. This view looks north up the Yakima River Canyon. One of Amtrak's special viewing cars is attached to this train. Highway 821 is visible to the right of the river.

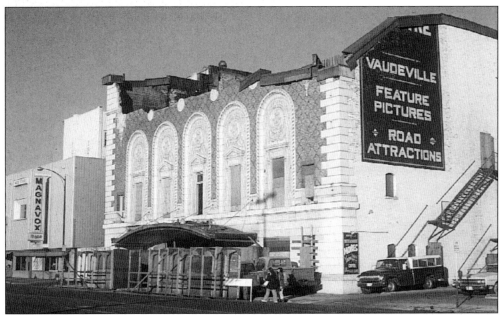

On April 18, 1974, ownership of the Capitol Theatre was transferred from the Mercy family to the City of Yakima. Just one year later, on August 11, 1975, a catastrophic fire engulfed the building. The city led the effort to rebuild the theater. Grants from Yakima County, Washington State Parks and Recreation Commission, and the Economic Development Administration and public donations financed the project.

The mezzanine level of the theater was recreated to its original design. Five large chandeliers light the interior, and two beautiful murals grace either end of the mezzanine. Here is A.B. Heinsbergen creating one of his murals. He supervised a team of painters that tackled other portions of the interior. The murals are painted on gold leaf and depict romantic scenes.

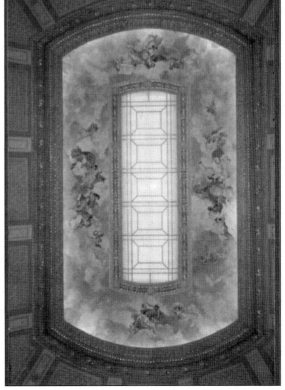

At the age of 83, Heinsbergen also recreated his original ceiling design, because the design was one of his favorites. He painted four canvases at his home in Los Angeles. The panels were cut into pieces before being installed in the dome, which is about 60 feet from the floor. A catwalk provided access to the ceiling. Special cove lights were placed in the dome to show off the design.

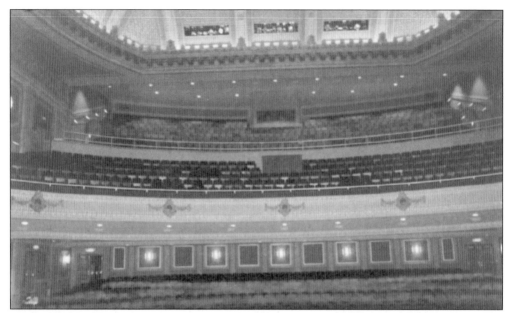

The original seats, used in Constitution Hall in Washington D.C., were restored. The seats were arranged to span the width of the auditorium. With the tiered arrangement of floor and balcony, there is no such thing as a bad seat. Around the front of the balcony there are 11 loges, each containing 8 Circassian walnut chairs—the best seats in the house. There are a total of 1,564 seats in the theatre.

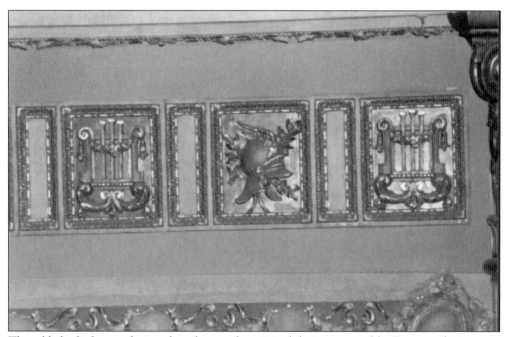

The gilded reliefs were designed as close to the original design as possible. Fortunately, just one year earlier, the Capitol Theatre had been placed on the National Register of Historic Places. Extensive pictures were taken at that time; molds for the new designs were made using these pictures and from designs salvaged from the rubble.

During the reconstruction, 7,000 square feet of debris and dirt were excavated from underneath the theatre. Several offices, a reception room, and this new foyer were added to the dressing rooms and kitchen that were already there. These rooms were sponsored by W.M. Robertson, chairman of the Capitol Theatre Trust and owner of the Yakima Herald-Republic newspaper. Gilt edges and velvet seat cushions were designed to complement the original 1920s decor.

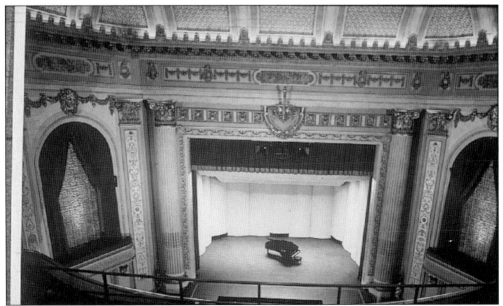

The theater was rebuilt using steel and concrete. The only exception is this beautiful stage. Wooden floors were retained so that the theatre could still be used for dance. New velvet draperies replaced the old asbestos curtains. State-of-the-art lighting and sound systems were installed. There is a hydraulic orchestra pit lift, which is raised to stage level in front of the curtains. An actor's lounge was added below stage for resting or waiting to go on stage.

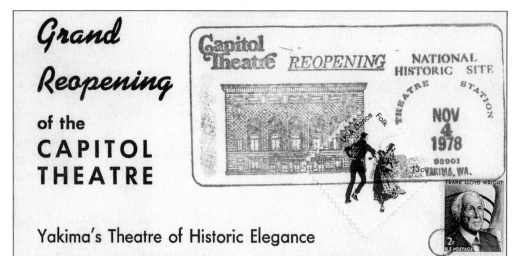

Grand Reopening
of the
CAPITOL THEATRE

Yakima's Theatre of Historic Elegance

It took 733 days, but the theater finally reopened in November 1978. On November 4, a grand reopening was held. The Yakima post office issued this special commemorative first day cover to celebrate the reopening. Obviously, the entire city felt affection for the city's "Little Jewel Box," as dubbed by painter Heinsbergen. At opening, the exterior dimensions of the new theater were 93 feet wide by 140 feet long.

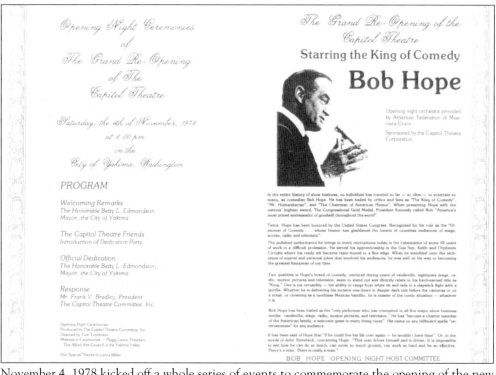

November 4, 1978 kicked off a whole series of events to commemorate the opening of the new theater. Governor Dixy Lee Ray and Representative Mike McCormack attended the opening night show. Show attendees arrived in classic cars, reminders of a bygone era. Bob Hope was on hand for opening night, entertaining visitors with his classic wit. Later that month Jose Feliciano performed, as did the Canadian Opera Company.

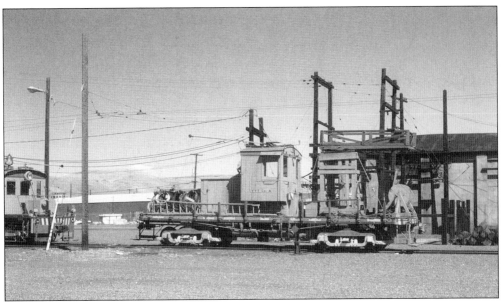

In 1974, the city began to restore the old Yakima Valley Transportation Company's electric trolley service. With the cooperation of the Union Pacific Railroad, 19 miles of track were reopened for shuttle service. This picture of Line Car A was taken in 1978, when it was thought to be one of the oldest interurban cars still in service. It was made by the Niles Car & Manufacturing Company in 1909. It was originally a flatbed car with a cab. In 1922, it was redesigned as a line repair car.

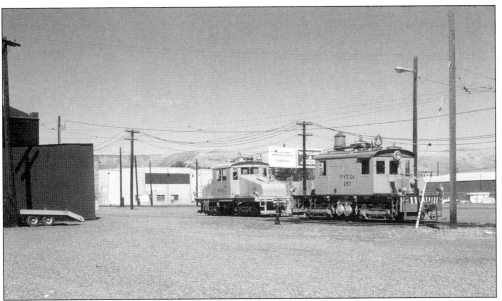

Cars No. 297 and No. 298 were electric locomotives. The Baldwin Company, long time builder of steam locomotives, manufactured No. 297 in 1923. It was acquired by the Yakima Valley Transportation Company in 1942. General Electric built No. 298 in 1922, specifically for the Yakima Valley Transportation Company. Both were still in service when this photo was taken in 1978.

After giving warning of her intentions over several months, Mt. St. Helens blew her top on May 18, 1980. Communities closest to the mountain were damaged the most. Yakima is about 100 miles away as the crow flies, and still felt the power of nature. This part of Yakima Avenue would normally be filled with Sunday afternoon shoppers at the mall. But dense volcanic ash kept people home. The dust created enough darkness that automatic sensors turned on the streetlights.

The northwest part of the city received the most ash, about an inch deep. The southern part of town and Union Gap received from one-fourth to half an inch. The refuse manager estimated about 600,000 tons of ash fell in the city limits. It was no deeper than a light dusting of snow, but it was very heavy. One man measured a coffee can full of ash at 13 pounds. These men are really getting a work out, using push brooms to sweep up the ash from the streets.

If anyone ventured outside, it was necessary to wear dust masks, as do these volunteer workers. It was thought that the ash contained silica that could possibly damage the lungs. No doubt it was hazardous for allergy sufferers. After being scooped up, some of the ash was used to fill in a vacant lot for a new city park. More ash was used to create an attractive new infield at the horse race track at the fairgrounds.

An enterprising company saw the marketability of Mt. St. Helens ash. This small package contains about four ounces of ash and gives a detailed description of the contents of the ash and the percentage of each element. It looks like ordinary sand but contains varying amounts of silicon, sulfur, calcium, iron, arsenic, and zirconium, to name a few. Others got in on the fun, creating many kinds of products out of ash, including glassware, jewelry, pottery, and cement products.

Certified

MOUNT ST. HELENS'
VOLCANIC ASH
FROM THE ERUPTION OF
MAY 18, 1980
FROM YAKIMA, WASHINGTON

INGREDIENTS: Silicon (Si) 43%; Sulfur (S) .48%; Chlorine (Cl) .18%; Potassium (K) 7.2%; Calcium (Ca) 21%; Titanium (Ti) 1.5%; Chromium (Cr) .21%; Manganese (Mn) .43%; Iron (Fe) 24%; Nickel (Ni) .0052%; Copper (Cu) .055%; Zinc (Zn) .072%; Gallium (Ga) .013%; Arsenic (As) .0070%; Rubidium (Rb) .057%; Strontium (Sr) 1.1%; Yttrium (Y) .050%; Zirconium (Zr) .43%; Molybdenum (Mo) .15%; Barium (Ba) .036%.

When the mountain blew, the ash spread in a generally northwest pattern and eventually all away around the world. The heaviest particles fell to the ground closest to the mountain. Finer particles stayed airborne longer. These samples show the different colors and fineness of grain as the ash blew further from Mt. St. Helens. Samples range from locations west to east, going further away from the mountain: Toutle River, Packwood, Ellensburg, Yakima, Grandview, Richland, and Ritzville.

In the fall of 1987, the county leased nearby Kissel Park to the D.D. Eisenhower High School. The school opened in 1957 on S. 40th Avenue. The park allows students in the agriculture program to grow plants and use pesticides. Mr. Mortimer talks to students (from left) Jeff Ryan, Brian Steen, and Jon Woods, about how a tractor works. The students worked hard to clean up an otherwise ugly plot of weeds and garbage.

In 1987, Yakima held the annual Sunfair Parade at the same time as the Central Washington State Fair in late September. These members of the Eisenhower High School marching band led the parade. Floats and bands came from all over the northwest to participate in the parade down Yakima Avenue. The Eisenhower Band and Drill Team won first place in their categories.

Despite losing several seniors, the Eisenhower Cadets posted a winning record in 1988. The cadets were coached to its first league championship with a 15-5 record. Pictured, left to right, are: (front row) Eric Pue, Greg Crawford, Mike Kelly, Eric Pelkey, and Sean Murphy; (middle row) Todd St. George, Ron Zerr, Mike Baily, Dave Johnson, George Leitch, and Chris Hoggarth; (back row) Coach Oliphant, Mike Treat, Steve Shilman, Pat Leahy, Greg Forrest, Scott Hatteberg, and Coach Johnson.

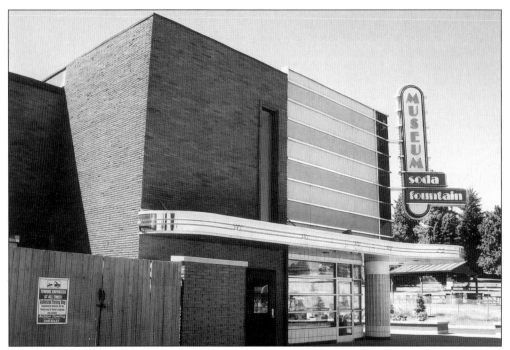

Groundbreaking for the Yakima Valley Museum occurred on June 21, 1956. A permanent museum was necessary because the collection at the city hall was beyond its capacity. The Alexander Miller estate donated $65,000 for the new building. Publication donations accounted for the rest. The museum is now located at Franklin Park on Tieton Avenue. Between 2000 and 2002 the museum underwent a massive remodeling to accommodate more and better exhibits and gifts.

This panoramic view of Yakima was taken from Resthaven Road, looking south. The dirt road runs from Selah Gap to the Terrace Heights district in east Yakima. The hazy look in the center of the picture is not pollution, but the many sprinklers that are used at the Cascade Lumber Company to keep the logs wet. The 13-story tall Larson Building still dominates the landscape. To the south is Ahtanum Ridge.

This comfortable-looking neighborhood is one of the newer developments in Yakima. These houses are on the north side of a ridge that no doubt has its own micro-climate. Appropriately named Scenic Drive provides access to the area.

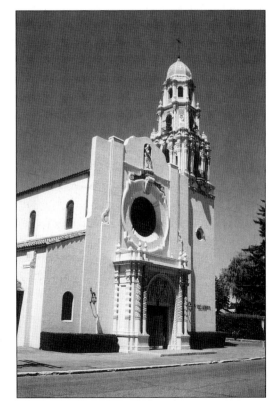

The first service to be held at St. Paul's Cathedral was on April 18, 1927. The church, located at S. 12th Avenue and Chestnut, is designed with Spanish mission architecture. Reverend Robert J. "Father Bob" Armstrong presided over the church at the time. The church looks much the same today as it did when it was first built.

A.J. Switzer built the Lund Building from solid rock in 1898. The corner was angled to match the corner of the lot. The building, on Yakima Avenue and Front Street, was used by a variety of businesses including the Alfalfa Saloon. The saloon was sold in 1910 and the space was converted to a men's clothing store—Chicago Clothing Company operated there until 1968. Today Corday's, a small boutique, and Greystone Restaurant occupy the street level spaces.

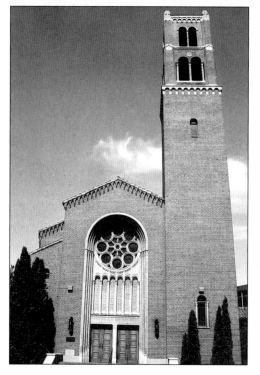

The First Presbyterian Church, at Yakima and S. 8th Avenues, was built in 1927 for $300,000. The predominant architecture is Romanesque style. It has two rose windows and 11 clerestory windows. The church gym was used for inter-church basketball games, roller skating, and plays. Yakima Valley Community College also has used it for P.E. classes. The Ward Memorial Chapel was built on the lot in 1963, to commemorate a pioneer family.

When Miner's opened in 1948, it was known as Miner's In-N-Out. Ever since then, Edward and Irene Miner's store has been a Yakima favorite. The Big Miner is a burger that will challenge even the heartiest appetites. In 1974, the name was changed to Miner's Drive-In Restaurant. The restaurant is one of the few drive-ins that requires the passenger to order and pay!

The Yakima Greenway stretches for 10 miles, encompassing 3,600 acres, from Selah to Union Gap, with Yakima in the middle. The asphalt pathway, which parallels the Yakima River, is perfect for joggers, walkers, cyclists, and skaters. Fisherman and bird watchers also enjoy the natural area. The Greenway has been designated as a National Recreation Trail. Pictured is Sarge Hubbard Park, on the Greenway. Hubbard was instrumental in establishing the Greenway.

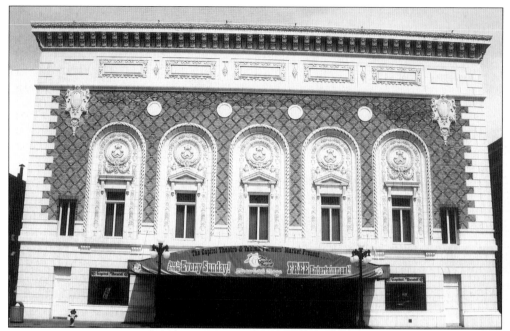

The Capitol Theatre is still in use today, sponsoring many local and regional events. It is used for performances from ballet to opera to rock n's roll music. The theater can also be rented for any event. Businesses can also use it for meetings or lectures.

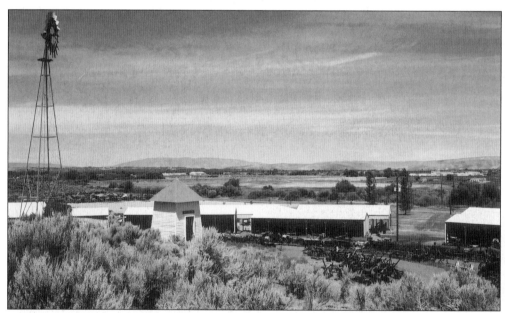

Though technically within the city limits of Union Gap, the Central Washington Agricultural Museum preserves relics from the entire Yakima Valley. The museum opened in 1979 at Fulbright Park on land donated by the Fulbright family. Nineteen buildings house various types of farm machinery from around the Yakima Valley, including wagons, tractors, a sheepherder's wagon, threshing machines, and many others. The museum stores relics from other areas, including this working windmill from Rosalia, Washington.

Washington Middle School, located at 501 S. 7th Street, was built in 1923. It is thought to be the first school in the state to be built as a junior high school. A.F. Gehring came from Ohio to operate the new school since no one local had any experience with developing a junior high school. In 1988, it became a middle school when a statewide effort returned ninth grade to the high schools.

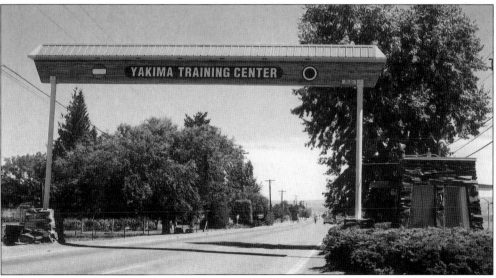

This is the entrance to Yakima Training Center, as it is now known. In 1990, the name was changed from the Yakima Firing Center, as the new name was thought to be more descriptive of its activities. The center now contains 323,000 acres and serves active duty, National Guard, and reserve units. It also serves as a multi-national training center, as units from other countries train under hot and dry desert conditions.

The Del Monte Corporation cannery and its water tower has been a part of Yakima scenery since 1934. Though the plant always produced Del Monte brand products, the company didn't change its name from California Packing Corporation to Del Monte Corporation until 1967. Del Monte was the first major food producer to include nutritional information on its labels. In Yakima, the cannery is especially busy during apple and cherry harvests.

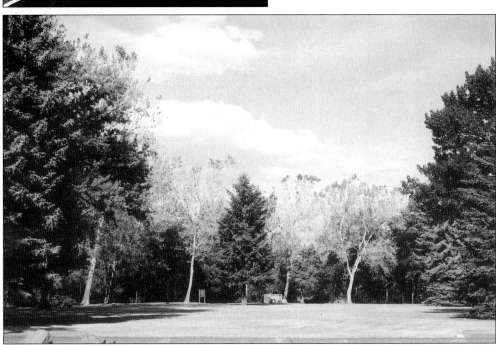

Sportsman's State Park is situated along the Yakima River. Originally developed in about 1952, the park now encompasses 250 acres, most of which are undeveloped. The site is primarily a picnic and play area, though there are several dozen overnight camping sites. Kids can also fish at a pond stocked especially for children.

The Yakima Valley Sundome, formally known as the Washington State Agricultural Trade Complex, is an 85,000-square-foot facility. Agricultural exhibits, trade shows, symposiums, conventions, and concerts all take turns in the Sundome. It is also the home of the Continental Basketball Association Yakima Sun Kings. The stadium seats 8,000 and holds 322 booths. Though a modern facility, its designers remembered the valley heritage with a Native American design around the exterior of the dome.

Downtown Yakima is the location of one of the more unusual shopping districts in the area—Track 29. This district consists of a row of old railroad cars that have been converted into shops and restaurants. Their colorful paint jobs and quaint decor remind shoppers of a bygone era. Behind these buildings is Yesterday's Village, a huge antique mall located in the old Fruit Exchange Commission building.

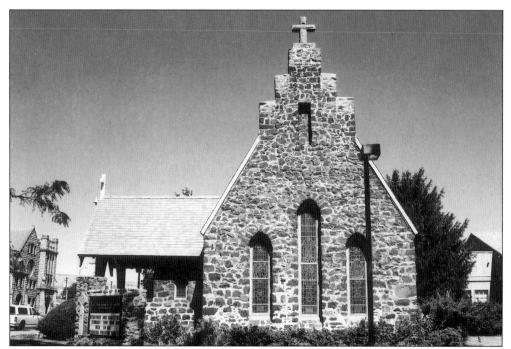

St. Michael's Episcopal Church is the oldest church in Yakima. The church was built in 1888 and the rectory was built in 1899. Both still stand today on the corner of Yakima and Naches Avenues on land originally donated by the railroad. The church is made from basalt. The glass was shipped from Cincinnati. Today it is twice the length as it was when originally built. The building was placed on the State Register of Historic Places in 1977.

The construction of the Millenium Plaza, located on S. 3rd Street across from the Capitol Theatre, is being made possible through many generous contributions from individuals and businesses. Construction began in 2000 to provide a comfortable meeting place that inspires community pride. The concrete blocks to the extreme right and left of the picture contain glass-encased relics of history. The freestanding rocks display bronzed antiques, such as an old sewing machine and an old saddle.